The TV Career Handbook

"Oh Kathryn! Why didn't you write this book 20yrs ago?! If you read this book and don't cultivate a successful presenting career, you didn't read it properly."

Ortis Deley, Presenter, The Gadget Show

"This is a smart, well-planned, and valuable handbook which is chock-full of useful material."

Dr. Paul Elsam, Senior Lecturer in Performance, Teesside University, UK

You can present to camera, speak to time, read from a prompt, conduct an interview, write and memorise scripts; you have a showreel, headshots and a CV—but what next? How do you decide which genre to go for, how to market yourself and establish your career? *The TV Presenter's Career Handbook* is full of information and advice on how to capitalise on your presenter training and contains up-to-date lists of resources to help you seek work, market yourself effectively, and increase your employability. Contents include raising your profile, what kinds of companies to aim for and how to contact them, what to do with your programme idea, video and radio skills, creating your own TV channel, tips from agents, specialist genres such as News, Sports, Technology, Children's and Shopping channels, breaking into the US, and more! Features interviews and case studies with over 80 experts so you can learn from those who have been there first, including: Maxine Mawhinney BBC News anchor, Jon Bentley and Jason Bradbury presenters The Gadget Show, Melvin Odoom KISS FM, Gemma Hunt presenter Swashbuckle, Matt Lorenzo presenter Premier League, Tony Tobin chef/presenter Ready Steady Cook and Saturday Kitchen, Alison Keenan presenter QVC, Maggie Philbin and Jem Stansfield presenters Bang Goes the Theory, Kate Russell presenter BBC Click, Sarah Jane Cass Senior Talent Agent Somethin' Else Talent, and Claire Richmond founder findatvexpert.com

Kathryn Wolfe is a highly experienced TV Director with credits including BBC's Breakfast Time, Record Breakers, The Clothes Show, Teletubbies and Tweenies, and since 2006 she's been Course Leader Television Production and Senior Lecturer Media Performance at the University of Bedfordshire. For more than ten years she has devised and delivered short courses in TV Presenting across the UK, in addition to delivering TV presenter training in HE, coaching hundreds of TV presenters and launching countless careers. See www.pukkapresenting.co.uk

The TV Presenter's Career Handbook

How to Market Yourself in TV Presenting

KATHRYN WOLFE

Focal Press
Taylor & Francis Group

NEW YORK AND LONDON

First published 2015
by Focal Press
70 Blanchard Road, Suite 402, Burlington, MA 01803

and by Focal Press
2 Park Square, Milton Park, Abingdon, Oxon OX14 4RN

Focal Press is an imprint of the Taylor & Francis Group, an informa business

Notices
Knowledge and best practice in this field are constantly changing. As new
research and experience broaden our understanding, changes in research
methods, professional practices, or medical treatment may become necessary.

Practitioners and researchers must always rely on their own experience and
knowledge in evaluating and using any information, methods, compounds,
or experiments described herein. In using such information or methods they
should be mindful of their own safety and the safety of others, including
parties for whom they have a professional responsibility.

Product or corporate names may be trademarks or registered trademarks,
and are used only for identification and explanation without intent to infringe.

Library of Congress Cataloging in Publication Data
CIP application submitted.

ISBN: 9780415856980 (pbk)
ISBN: 9780415856973 (hbk)
ISBN: 9780203709313 (ebk)

Typeset in Dante and Avenir
By Keystroke, Station Road, Codsall, Wolverhampton

Printed and bound in Great Britain by
TJ International Ltd, Padstow, Cornwall

Dedicated to my wonderful family especially Arif, Omar, Soraya and Rose who listened patiently to my ramblings during the writing of this book, to my understanding and supportive friends, and the amazing TV presenters whom I've worked with over the years.

Contents

Introduction

I spent nearly 30 years as a freelance TV Director working on hundreds of different commissions and programmes for a variety of production companies and broadcasters. To find jobs I relied on self-promotion, finding and keeping contacts, self-marketing and creating my own opportunities. During the whole of this period I was almost always in regular work, generating TV ideas, becoming attached to TV shows, carving an exciting and successful career in mainstream TV directing mainly for the BBC and ITV.

At that time production jobs in TV were rarely publicised, just the occasional advert in UK trade papers such as *Broadcast*, *The Guardian* media pages or *The Stage* newspaper. I had to keep my ear to the ground and create my own career path. Sacks of letters, stamps and envelopes, days of phone calls and face-to-face meetings – I could paper the walls with rejection letters! But I had confidence in my abilities, my training at the University of Bristol and the BBC gave me a fantastic start in my chosen field, and I kept going. In my entire TV career I didn't have a staff job. My longest contract was for one year, most jobs were for a few months or weeks, and occasionally just for one day – luckily a one-day contract at London Weekend Television directing a live outside broadcast for *The Six O'Clock Show* led to ten years of high-profile work at the company.

Before Channel 4 was launched in 1982 there were only three channels, BBC1, BBC2 and ITV, which in terms of job-seeking had advantages and disadvantages. The pool of Executive Producers I could approach was relatively small, and once I had completed a successful project my name was passed on (usually!). On the other hand, there were fewer possibilities as less programming was being made than in our current multi-channel market.

Today's shifting media landscape means we all need to keep up with changes that affect the way we seek work: increased channels, growth in online viewing, more accessible recording equipment and editing software, social networking and, importantly, significantly greater opportunities for marketing and self-promotion.

It still is true that you need to make your own luck, find contacts, open doors, and generally speaking you are only as good as your last job. There is no conventional career path in the creative industries; self-sufficiency is the key to most performing arts careers, and each person will have a unique story of how they made it. However today's job seekers have so many more opportunities at their fingertips – online job adverts, websites dedicated to job seeking and promotion, headshots, CVs and reels emailed or viewed via a link, job alerts arriving by Twitter or text, information sharing, plus the fragmentation of TV and radio channels – leading to endless production and presenting possibilities.

These technological changes have affected TV presenter training. As well as needing TV presenting skills, increasingly students are asking more about careers and how to shape them. I have taught many hundreds of TV presenters – in higher education at the University of Bedfordshire, in adult education at City Lit and The Actors Centre, at the Academy of Live and Recorded Arts (ALRA) and in private coaching. My directing background enables me to teach performance and advise how to develop talent. After presenters have learned the basics the most common questions are: 'How do I market myself?' 'How do I go about finding a TV presenting job?' 'What area of TV presenting should I go for?'

Presenters with experience are also asking 'How do I move from niche programming to mainstream productions?' 'How can I enhance my career and raise my profile?' The aim of this book is to offer advice to new presenters facing the challenges of breaking in, and to those who are seeking to refocus their career.

Why now? I have watched with delight as presenters who I've coached have gone from strength to strength – many are regulars on mainstream TV and online channels, leading very active careers in the industry. This book builds on my first book *So You Want to be a TV Presenter?* and is based on knowledge I have built up by guiding presenters how to market themselves. It contains a wealth of interviews with more than 80 different presenters and experts. More and more people are seeking presenter training now as online and web presenting opportunities open up and TV production continues to thrive.

Employability is key – make yourself as employable as possible. You may need to become more multi-skilled than you are now, recognise your strengths

and confront your weakness, understand the market and how you fit into it, and use your existing expertise to open doors.

Do you have some TV presenter training? Have you started to make a showreel? Are you already presenting? How can you get your TV presenting career going in the right direction? In this book you will find advice and practical guidance to enable you to become more self-sufficient, more employable, build on your existing skills, generate opportunities, and help you to shape your career.

How do you make a splash when there are so many presenters out there? How do you get noticed and build up a profile? Where do you start when there are so many potential employers?

In Part One, Reality Check, you must ask yourself some questions. Do you have the appropriate skills to become a presenter and are you marketing yourself effectively? Skills can be developed with training but do you have the right qualities to be a successful presenter? This is a bit trickier, as some qualities stem from your personality and are harder to teach, but we are all capable of acquiring new habits!

Part One includes top tips from career advisers, refreshers on TV presenting skills, up-to-date marketing information and interviews with agents who explain what they are looking for now.

The current fashion is to employ presenters who are experts in their field to give shows more credibility. The proliferation of bespoke channels has contributed to the rise of the specialist presenter. Part Two, On the Case, reflects this growing trend of the expert presenter. Different genres of presenting are explored from sports to science, finance to food, and news to shopping. We hear first-hand from new and established presenters how they got in to the industry and what the expectations are, and give you the latest information on how to break into a wide range of different presenting genres. Case studies with up-and-coming presenters and with household names reveal current industry practice; producers and TV production teams explain what you need to succeed.

Part Three, Channel Your Ideas, looks at what to do with your TV ideas and how to get them made. In this chapter you will learn what makes a successful TV proposal and pitch, and read case studies of presenters who have created their own Internet channels.

If lack of technical knowledge in shooting and editing is an issue, this topic is explored in Part Four, Using Video. Follow the example of presenters who have added video to their websites and produced their own showreels. Technicians in video, sound and editing give top tips on how to produce the best results.

Convergence, or a merging of different media, helps you to create a portfolio career across different but interconnected media. The speed at which the industry is changing is also a constant challenge. Part Five, Using New Media, explains how to tackle new media to help determine your career, using social media to increase your digital footprint.

Finally, in Part Six, Using Radio, experts explain the similarities and differences between TV and radio, and how to use radio to enhance your TV career. Radio presenters, producers and lecturers reveal what you need to know to master the art of being a successful radio presenter and how it relates to TV presenting.

Each chapter ends with a 'to do list' of practical ideas to follow up, suggestions of current and relevant websites, programmes, books and resources to explore. To get the most out of this handbook you will need to do your bit too – not just passively read the chapters but work your way through the suggested activities.

This book looks behind the success stories of presenters who stand out from the crowd, who are employable, who have added to their TV presenting skills, made an impression with their original ideas, and even launched their own Internet TV channels making the leap to mainstream TV, not just as presenters but as producers of their own material and content. Although the nature of TV is that current shows and presenters may change, the advice given will remain valuable for the foreseeable future.

The TV Presenter's Career Handbook covers a range of presenting from mainstream high-profile television productions to online TV channels and web presenting. It is written as a guide that can be read in a non-linear way if you wish – just dip into the relevant chapters – or read it from beginning to end. TV presenting careers are unique – individuals make their own career path with distinctive credits – but whatever your background or aims for the future the following chapters will give you the skills to analyse where you are now, where you want to be, and how to get there!

The TV Presenter's Career Handbook will help you decide which paths to follow and give you the information you need to kick-start your presenting career.

Good luck!

Kathryn

Part One
Reality Check

one
Personality Check

Welcome to *The TV Presenter's Career Handbook*. You don't have to be a TV presenter to benefit from this book because much of the content applies to people in a wide range of creative industries and performing arts. But if you are a potential TV presenter thinking of entering this industry, a media or performance student or practitioner, a new or experienced presenter, someone with a specialism that can be used in TV presenting, a professional who is thinking of a career change, or anyone with an interest in TV presenting or broadcasting – read on.

This section is called Reality Check because, whist TV presenting is perceived as a glamorous profession, the reality is somewhat different. Of course, being in the industry has fantastic moments – from being on the red carpet to interviewing high profile guests in fabulous locations – but the reality is that TV presenting requires a huge amount of energy, commitment and preparation. Do you have the right personality to cope with the rigours of the job?

Start by thinking about you. Consider your character, temperament and qualities. Recognise your strengths and weaknesses. Try to evaluate objectively how you come across and realise how others see you.

One of the first questions I ask presenting students is 'Why do you want to be a TV presenter?' This is not a trick question, it could come up in a job interview in almost any field – celebrity, glamour and wealth are probably not the right answers here!.

What motivates you to present? It could be that you want to communicate to a larger audience, you enjoy interviewing and finding out about other people, there is an issue you want to promote, you have role models who are TV presenters, or you want more variety and challenge in the workplace. It

might be that you are already writing, producing or broadcasting, in TV, radio, print or online, and you want to be more mainstream or high profile. Alternatively, you could be someone who has watched from the sidelines or from your sofa, and you've been thinking 'I could do that!'

Most TV presenters are freelance and motivation is a key quality to possess, so ask yourself if you really have the personality to go for it – it is a competitive business, and you will need to convince others that you're really keen and committed.

Darsh Gajjar, an Employability Adviser working in higher education, says: 'If you want to break into the industry and pursue a career as a TV presenter you have to be a 100% committed networker, with drive and motivation to exploit and create your own opportunities and take on board criticism and develop accordingly.'

Are you a self-starter, happy to contact people you don't know and ask them to employ you? Do you enjoy meeting new people, would you be able to work alongside a myriad of different colleagues and technicians?

Do you display initiative or do you prefer to be given instructions at each stage? Do you work well in a team or do you like to work independently? Are you persistent and tenacious or do you give up at the first round? Are you fairly thick-skinned or do you take rejection personally?

Can you think on your feet? How well would you cope if the top news story were replaced while you are live on air, reading from a different script? You can train for breaking news, so don't panic, but it is worth bearing in mind that some people work better under pressure than others.

Are you good at researching a topic, becoming an instant 'expert' in a wide variety of discussion points to put to the viewer or interviewee? Can you digest technical information and deliver it to the viewer in easy bite-sized chunks? Are you confident, with a friendly manner, do you possess good communications skills? How is your personal grooming?

The basic skills of presenting are summarised in Chapter Two, Skills Check, but that is not the whole story. A professional attitude will help you go far.

According to John Byrne, Entertainment Industry Career Adviser at *The Stage* newspaper, the following qualities could make you more employable:

- ❏ A strong awareness of your own strengths and weaknesses so that you target jobs people can actually employ you in, rather than just jobs you would like.
- ❏ An awareness that being a presenter is not being the person in the spotlight so much as it is being the public face of a programme making team (whether that team is two people or 50).
- ❏ Professional conduct at every stage for the benefit of the whole team.

Many presenters agree with the above comments. Do you have the necessary talents or could your attitude be holding you back?

Kate Russell, presenter on top BBC technology show *Click*, describes a successful presenter:

> Passion, knowledge, commitment, articulate, quick-thinker, empathic. You have to be able to work hard for long hours and keep smiling merrily while you are doing it; especially in the beginning before you have made a name, as most productions you work on will be underfunded and everyone overstretched. The easier you are to work with the more repeat jobs you will get – freelance production staff get promoted and move on to other productions that might be looking for a presenter, so treat everyone you work with as a potential employer!

Be honest with yourself and take a cold hard look at whether you're in the right place. Take advantage of online personality tests – they can be very revealing, with questionnaires that can help you to assess your qualities and priorities. See the resources list at the end of this chapter for links.

Prospects is a free graduate careers site that will match your skills, motivations and desires against more than 400 occupations to find jobs and courses that suit you. You don't have to be a recent graduate to use the site. The online quiz takes around 15 minutes and in my case it was fairly accurate, recommending theatre director, commissioning editor, TV floor manager or production manager as a career, although it also highly recommended architect! The recommendations can only be linked to the information you supply, so if you are not convinced about the job matches you can tweak and re-edit your questionnaire. The site has plenty of information on jobs, case studies, work experience and advice on how to prepare for job interviews – even the tricky ones!

The National Careers Service has Skills Health Check Tools, again it's a free resource that helps you to find out what kind of work is right for you. Even if you are 100% sure that TV presenting is what you want to do, the online questionnaires help you to find out more about yourself with assessment of your personal skills, activity skills, interests and motivation. The key qualities in my report were: leading and taking responsibility, persuading and communicating, creating and innovating – I'd like to think this is an accurate reflection of myself. The questionnaires only took a few minutes each and recommended that working in a creative environment was most important for me, that I am a 'doer', someone who thrives in practical production, who enjoys a dynamic environment and that I am people-focused. Spot on!

Profiling for Success has an excellent tool to explore your personality preferences in relation to the world of work, in addition to assessing your abilities. It's an online resource and you pay for each test that you take.

Another approach is the Jungian theory of personality types. Carl Jung, the famous Swiss psychiatrist, proposed the concepts of extraverted and introverted personality. By assessing your personality type you can work on your personal development, particularly useful when reflecting on your career choice and understanding yourself. It's about recognising who you are and how you work best – it's no good entering an industry that doesn't suit you.

If you take this route of personality testing, be candid with the answers – you needn't show them to anyone else! Or, you could ask your friends what they really think, although that could turn out to be embarrassing!

To do list

- ❑ List your strengths and weaknesses.
- ❑ Evaluate presenter qualities and match them to your own.
- ❑ Analyse your personal motivation and abilities.
- ❑ Explore online personality tests.

Click, read, discover

Online personality tests and career advice

https://nationalcareersservice.direct.gov.uk/tools/skillshealthcheck/Pages/default.aspx
www.profilingforsuccess.com/profile-yourself.php
http://prospects.ac.uk

Interview advice

http://careers.theguardian.com/careers-blog/star-technique-competency-based-interview

US

http://career-advice.monster.com
www.careercc.org

two
Skills Check

TV presenting is a skills-based profession; you will need to prove to your agent, director or producer that you can do it! Screen tests are exactly that – they test what you can do on the screen and how you relate to the camera / viewer. Your aim is to show employers that you have the skills and personality to handle whatever is asked of you in an audition.

So what can come up and how do you deal with it? There are many training opportunities on offer, from one day short courses to degrees in Media Performance or Acting that incorporate TV presenting. If you do not have training it is highly advisable to get trained, although if the producer really wants you to do the job and you are not trained, then it is possible to be given a crash course to get you up to speed. The risk with this approach is that your best work, when you have gained confidence, may not be until the last recordings of the show!

Here is a brief refresher of basic presenter skills that you will be expected to have:

Be yourself

Presenting is about being you; it is not acting, or pretending to be a presenter. You should not 'be in character' as when acting, but have the confidence to be yourself.

Talk to the camera

Reach your audience through the camera lens, so engage with the viewer by speaking conversationally to the camera. Look directly at the camera lens most of the time, except when you look at your guest, co-presenter, props or script as appropriate. In real life we may look out of the window or at the floor when talking to someone, but this doesn't really work on TV as it breaks the bond with the viewer, making the presenter look shifty. When speaking in public you should look at everyone in the room, but for TV keep your eye-line focused on the lens.

Perform for video

There is no need to use larger than life expressions or project your voice as the camera and mic will pick it all up – it's about performing for a screen, which is not the same as public speaking or performing on the stage. Typically today's TV screens can be 55–65 inches widescreen, magnifying any insincerity in the face. Being real is important. Give a performance with energy, which does not mean shouting or being over the top. Present as if you are the host of a dinner party – you at your best!

Speak to one person

It can be off-putting talking to a camera and trying to make it seem natural, so most presenters imagine the camera is their best friend or one typical viewer. On the whole we view TV on our own or with one or two people in the same room, so keep the tone conversational and befriend the viewer as an individual, rather than talking to a large audience. The same holds true for radio presenters – speak as if you are talking to one listener at time, because we tend to listen to radio on our own.

Relax and smile

Talk to the camera lens without getting a tense face, keep relaxed, smile and breathe! Breathing is the key to relaxation, so breathe deeply from the lower tummy area rather than from your upper chest to keep a strong core and prevent the neck and throat from tensing up. A relaxed, warm expression

conveys to the viewer that you are comfortable in your role, enjoying presenting and not nervous (even if you are secretly nervous inside!). Don't have a bolt-on smile or one that looks insincere! Your smile should come from presenting content you are enthusiastic about, except for news broadcasters who should remain emotionally neutral – but even so they should have a sparkle in the eye.

Calm breathing overcomes nerves and the inevitable adrenaline rush that comes from being outside your comfort zone. A bit of adrenaline can help lift a performance, too much can ruin it!

Good posture

Good posture gives authority and allows you to take in more air when breathing, which in turn leads to relaxation. The Alexander Technique is a popular method of improving posture, used by performers, dancers, sportsmen and women and musicians; imagine making 'spaces' between your vertebrae to grow taller, imagine lifting your body out of your hips to avoid slumping, and imagine your shoulders growing wider apart to make your upper body more spacious. It is not about pushing your bust forward and shoulders back, nor lifting your chin in the air – on the contrary, keep the back of the neck straight, smoothing out any kinks in the neck and widen the shoulder blades.

Clear diction

A presenter's toolbox includes good vocal technique and clear diction. If you are watching a presenter on TV, try closing your eyes and see if you enjoy listening to them too. Not only that, a good voice could help you to gain radio bookings. Warm up the face and throat with exercises such as tongue-twisters, freely available online. It doesn't matter what regional or national accent you have, broadcasting moved away from RP (received pronunciation, or the Queen's English) some time ago. What does matter is that viewers and listeners can understand what you are saying. Don't mumble and avoid lazy speech. If you pronounce 'three' as 'free' or 'thought' as 'fought' then it changes the meaning of the sentence!

To sum up: talk to the camera in a clear, warm tone, engaging with the viewer, connecting and communicating with the audience through the lens.

Ad lib

Presenters need to be able to ad lib (talk off the cuff, not scripted). You may need to fill if the guest is running late or there's a technical delay, or you may have to answer unscripted questions on a live show. Practise talking for one or two minutes about a variety of topics to get used to hearing yourself talking aloud – but do not waffle! Keep it structured and to the point.

Talking to time

Speaking accurately to time is a skill that's used particularly on live shows, but you may also need to talk to time in pre-recorded programmes to reduce the amount of editing. The general rule for calculating broadcasted speech is three words a second, so a ten-second script has about 30 words and a 20-second script has about 60 words. This is only a guide, as words are different lengths and people speak at their own pace, but if your 30-word script takes seven seconds to read aloud then you may be either speaking too quickly or you've used very simple monosyllabic words. Conversely, if your 30-word script takes 15 seconds to read aloud you may be speaking too slowly or you've used complex, long words. It's the screen time that matters here, not the word count. A producer will expect you to fill a set duration accurately, and will not ask how many words you are using – the word count is just your personal guide to help write the required length of script.

Timings

In a TV studio or on location you will be given timings via the floor manager or a member of the production team using hand signals or via in-ear talk-back. If you need to speak for ten seconds accurately – in, for example, a live trail for your show – timings will be given to you counting down from ten seconds to zero. You need to finish speaking just before zero, not after! TV shows run to predetermined schedules; if you overrun the timed pro-gramme slot, it will interfere with the all-important commercials, trailers or videos from the sponsors, and you might find your broadcast is cut off the air mid-sentence.

You can practise this at home. Make a pre-recorded countdown to play in your ear through your headphones, or get a friend to count the seconds from a stopwatch as you deliver your piece to camera. If you're doing, say, a

three-minute interview, the countdown could be every 30 seconds until the final ten. So you will be given the following counts 'two minutes 30 left', 'two minutes left', etc., until 'counting out of interview, ten, nine, eight . . . zero'.

Scripting style

TV scripts should be written in a conversational manner, as it's a spoken medium. Try reading a corporate brochure aloud – would it work on TV? No, it's a different style. Write for your target audience, avoid jargon and always read your work aloud before recording – that way you'll also hear if you've written any tongue-twisters or tricky phrases that might look great on the page but could trip you up!

Memorising scripts

You will need to be able to remember scripts and repeat them accurately (or near enough!). presenters and actors have various tricks for memorising scripts and information; you could try writing out the script in longhand, reducing it to bullet points, reciting it over and over again, or sleeping on it! One advantage presenters have over actors is that once the script has been recorded it can be junked, not repeated every night of the week and twice on matinees! The TV world works very fast, time is money, so you may not receive your script until the last minute. You'll need to practise learning lines quickly, and know them thoroughly to avoid endless retakes – bad for your own self-confidence and crew morale! I have worked on dozens of shows where there was no Autocue or prompt, so we relied on the presenter knowing the script.

Working with a prompter

Autocue, Autoscript, Portaprompt and other prompting devices scroll the script in front of the camera lens so the presenter can see it but the viewer can't. No need to learn lines! The presenter dictates the speed, so if you want to read more quickly, slowly or stop to make an unscripted remark, the operator will follow your pace. Most of the time there is an operator scrolling at the correct speed for you, but there are some instances where presenters use a hand or foot controller and scroll the script themselves, such as in BBC Parliament or regional news.

The trick with reading from a prompter is to speak to the viewer, not read to them. Remember the camera is behind the words, so look through the words to the lens. The script is generated from a Word document, so you can bold, italic, capitalise, underline, add colour, change font size or write phonetically such as 'Air Ton Senna' for Ayrton Senna. You should be given a hard copy of the script in advance to read through – check it thoroughly as this will have been generated from the same source as the prompter script. If there are mistakes on your hard copy you will face them as you read from the prompter!

Even if you have a prompter, make sure you are familiar with your script so that you know what is coming next. The prompter screen may not show the entire sentence at once, long sentences may not be completely visible – you'll need to know how the sentence ends to have the correct inflection. News presenters need to be very good at sight-reading from a laptop or prompter, as they may be faced with scripts they haven't seen before.

You may also have noticed that once they have read a story, news readers remove that script from the pile, so if the prompt should fail on story seven the presenter can go straight to the correct place in the hard copy. If you're presenting a show where it would be too bulky to hold a standby script, use smaller cue cards instead, or a tablet, which you can hold in your hand or have on the desk. There have been some high-profile disasters where presenters and celebrities have been faced with a prompter suffering a technical glitch – always have a back-up plan. You can rehearse reading from a scrolling screen at home using free prompting software – see below for details.

Walking and talking

Walking and talking – it doesn't sound too tricky to do both at once, but it's funny how some presenters forget how to walk normally because they are busy concentrating on talking, or vice versa! Know your script thoroughly and walk at a steady pace, not too fast or too slow. The camera operator or director should give you a start point and finish point for your walk, or if the script closes with 'Let's take a look!' you can walk past camera at the end. Be able to split the skills, so if asked to walk more quickly or speak more slowly you can separate the two tasks!

Vox pops

Vox pops can feature in TV or radio (they are also popular for showreels). The phrase is from the Latin *vox populi*, 'voice of the people', and it requires the presenter/reporter to approach members of the public to get a quick straw poll reaction to an issue. The interviewees are not formally set up in advance but are chosen during the filming process. You will need to know the question you'll be asking the public in advance, anything from their opinion on local politics to the price of fuel or, on a lighter note, the disappearing lunch hour. It requires confidence and a smile to go up to strangers, especially when you're accompanied by crew and equipment, so don't take it personally if you receive rejections! You need plenty of responses to edit together the best.

Interviewing

Interviewing is key for a presenter and much has been written about this topic. Central to being a good interviewer are the skills of research and listening. Although you do not need to be a qualified journalist to present (unless it's news), some journalistic approaches are needed in interviewing. Know the subject matter so you can prompt when necessary, get to the heart of the topic and enable the interviewee to reveal interesting information or emotion. Listen to their answers so you do not ask a question that has already been covered.

Put your questions in a logical order and try not to read them off like a list. You are there to put questions as if from the viewer, so if an answer is complex or incomplete, ask the question again for clarification. Look interested and keep control of the interview so you can shape it. A chatty interviewee in the green room can clam up in the studio, so be able to put your guest at ease (unless you are interviewing a politician!).

The demo

If you want to work on shopping channels then your basic but essential skill is the demo, or demo combined with an interview. Demo (short for demonstration) means showing how a piece of household, technical or sports equipment works, or selling jewellery, cosmetics, fashion or other products. You will need to know the key features of the item, who would be likely to use it, the price, quantity, etc. Shopping channels are usually live, presenters do not use a prompter or script, but instead can use out of vision cue cards containing

product information. The ability to ad lib and structure what you say is crucial, along with a connection to the product. Shopping channel presenters need to talk to time, work with in-ear talkback, and be able to perform without rehearsal. If you can present on a live shopping channel you will be learning some vital skills to carry with you for the rest of your presenting career.

The make

Makes – 'Here's one I made earlier' – are found in children's and arts and crafts programmes, when the presenter shows how to make an item from various props and materials. There are similarities to the shopping channel demo, and to DIY, cookery and gardening shows. The key things to remember are: be organised with your props; practise before the shoot; have the right glue, scissors, pens, etc., or the make will fall apart (this has happened on live TV). Try it out first, be prepared!

Protocol

Presenters should be familiar with studio and location protocol, and understand how to work in a multi-camera setting. Studios can have very large production teams – as, for example, on ITV's *Dancing on Ice*, or BBC's *Strictly Come Dancing* (*Dancing with the Stars* in the US) – although crews are getting smaller and more multi-skilled in news, shopping channels and location shoots.

Production teams use mics and in-ear pieces to communicate with each other, commonly known as talkback. A studio floor team can include the camera department, set design department, sound department and hair and makeup team, so the studio floor can be very busy. The floor is controlled by the floor manager and a team of assistants. The control room or gallery team is led by the studio producer and director, and staffed by the vision mixer, production assistant, Autocue / Autoscript operator, vision control, technicians, engineers, the operator to play in inserts and record the show, the sound supervisor, lighting designer and others. Team sizes can differ according to the production, and cameras sizes can vary depending on the facilities and equipment being used.

From the presenter's point of view, studio and location shoots each have their own potential distractions. It can seem that there are teams of people apparently staring at you as you deliver your pieces to camera, whereas in reality they are checking their departments – the camera operator checking

focus and framing, the lighting designer checking shadows and exposure, the sound operator checking sound quality, the production assistant checking continuity, and the hair and makeup department checking for messy strands of hair or a shiny forehead! So, keep focused, don't worry about people watching you, distracting movements of the crowd, or what size the camera is. As TV production works fast, with minimum rehearsal, you may need to wait around for hours then have to perform at your best, so pace yourself and keep calm.

Visit studios to get familiar with the environment, and get free audience tickets to view how TV presenters work and what the expectations are – see how slickly a live studio audience show is recorded.

Appearance

Finally, don't forget personal grooming. What do your clothes, hair and makeup say about you? Are you projecting the image you'd like to? Whether it's dealing with fashion accessories or checking your nails look good in a close-up, we could all benefit from some improvements and styling advice. Unlike actors, presenters rarely have the luxury of being offered hair, makeup and costume – you are responsible for your own look. Take advantage of stores that employ personal shopping assistants to help you choose outfits, and makeup counters that offer lessons or makeovers where products you buy are redeemable against the cost of the session. Free online tutorials show how to enhance your image, everything from choosing the right colour foundation to skincare for men. You can chat to your hairdresser for a new look to improve your image on screen – and off.

To do list

☐ Research TV presenter training courses.
☐ Start training or top up existing skills.
☐ Watch TV – analyse TV presenter skills and performance.
☐ Attend TV recordings.

Click, read, discover

Short courses include

www.actorscentre.co.uk – short courses in TV presenting, London
www.citylit.ac.uk – short courses in TV presenting, London
www.pukkapresenting.co.uk – bespoke TV presenter training

Higher education

www.alra.co.uk – ALRA, London and Wigan for TV presenter training within three-year Acting BA (Hons)

www.beds.ac.uk – University of Bedfordshire, Luton, TV presenter training within BA (Hons) Media Performance and PG Performing Before the Camera

www.tees.ac.uk – Teeside University, Middlesbrough, BA (Hons) Performance for Live and Recorded Media

US

www.emerson.edu/academics/departments/journalism/undergraduate-programs/broadcast-journalism – Emerson College

Books

Alburger, James. *The Art of Voice Acting.* Burlington, MA: Focal Press, 2010.
Houseman, Barbara. *Finding Your Voice.* London: Nick Hern Books, 2002.
Wolfe, Kathryn. *So You Want to be a TV Presenter?* London: Nick Hern Books, 2010.

Prompters

www.cueprompter.com – free web-based teleprompter
www.easyprompter.com – free web-based teleprompter
http://i-prompter.com – teleprompter for iPhone and iPad

Tickets for TV recordings

www.bbc.co.uk/showsandtours/tickets
http://lostintv.com
http://www.applausestore.com/home
http://sroaudiences.com

three
Marketing Check

If you feel you have the right personality and skills for presenting but you are applying for jobs without success, then take another look at your marketing strategy. Do you understand your unique selling point (USP) and your brand? What makes you special? Are your marketing materials fit for purpose? Do you recognise how to raise your profile using social media to help you sell yourself? Successful marketing is explored below, closely linked to working with an agent in the following section.

USP

'Unique selling point' or 'unique selling proposition' is a marketing term that indicates how your product is differentiated from similar products. Product? In TV presenting, the product is *you*! Decide what you can offer the industry. What makes you different from your competitors? Look at successful presenters and try to analyse what makes them stand out. If you clarify your USP it will enable you to speak with conviction at job interviews and screen tests, as well as aid you in creating a CV, covering letters, websites, blogs and marketing materials that set you apart from the crowd.

Spotlight is the leading directory for performers. Its Senior Editorial Assistant, Cindy Dean, says:

> There is a vast amount of competition out there and many production companies prefer hiring people who have had previous broadcast experience or are experts in their field. It is good to know what kind of presenter

you want to be and make sure it is reflected on your CV and showreel. Have a unique selling point giving you a reason to present. There are fewer opportunities for general presenting.

New presenters often ask me what genre they are suitable for, what type of programme should they present – they do not know their USP. My response is that if they have an area of expertise, anything from apple-growing to zoology, they should use it to open doors.

John Byrne is an Entertainment Industry Career Adviser with a weekly column in *The Stage* newspaper.

> There are probably more opportunities for new presenters than there have been at any time in the history of broadcasting. However, there is more competition from other presenters than there has been at any time in broadcasting history. The challenge for any presenter is precisely the same as it has always been . . . to move from being 'a presenter' to being '*the* presenter' that producers and audiences think of first when they wish to commission or watch a show.

David McClelland is fast becoming *the* technology presenter – with BBC's *Rip Off Britain*, *Gadget Show Live* and a huge range of online technology programmes as credits. David started out as an actor with an interest in presenting and technology, but his TV presenting career took off when he branded himself as a technology specialist. He understood the importance of having a USP, clarified his presenting career path and became known as a technology expert.

> A large part of successfully building a profile is about understanding your key selling points and then creating a brand for yourself around those. I brand myself as a technology expert and broadcaster. Both my website and social media presence are very visible parts of my profile and ones that I work hard to develop. Writing for relevant publications and websites is another area that has worked well for me, and I've landed work in the past simply on the basis of having written a blog post for a particular title. Promoting associations with respected publications and organisations is another important part of my profile-building. The important thing behind these activities is they are all consistent and help to promote your brand.

Fran Scott is a science presenter whose credits include *Absolute Genius with Dick & Dom* and *How to be Epic @ Everything*, both for CBBC, as well as work on

Radio 4 Extra, BBC Learning and BBC Worldwide. Fran's USP came about through recognising a gap in the market.

> I realised that there was no one like me presenting science programmes, especially children's shows. It had become a habit for science shows to get ladies with no science qualifications to say words that they themselves didn't understand. I thought this was wrong. It was acting. Some presenters on science shows didn't seem to have passion, didn't seem to care what they were talking about, and so neither did the viewers. And, at the other end of the scale, you had those who undoubtedly knew their stuff, but were just plain dull to watch.

Andrew Wilson, Founder of Cloud9 Management Ltd talent agency and Fran Scott's agent, adds: 'Ask yourself this question: "Am I the leading expert in my field, a field that has broad general interest and appeal, or have I got the credibility and charisma to make it broadly appealing?" If the answer is yes then give me a call.'

So, apart from TV presenting skills, do you have other areas of expertise or interests that you can exploit in your job search? Any specialisms, qualifications or achievements that are transferable?

Sarah Jane Cass, Senior Talent Agent at Somethin' Else, confirms: 'It's certainly a more competitive market for presenters trying to break into traditional TV and radio and it's not enough now to just be a good presenter. You need to have expertise or specialist knowledge and really know the subject you want to go into.'

Being the expert

If you're not an expert but interested in more general presenting, you need to have something different to offer – a striking personality, wit, a following or an unusual way of looking at life. It is much easier to establish a presenting career if you are an expert.

There are a number of promotional websites where you can upload your details, list your expertise and be searchable by category – for example, interior designer, economist, or gardener. The more your name is out there, the more likely it is that you will be noticed and picked up. There are no guarantees, but at the start of your career you need to find the jobs, they will not find you. There are regular initiatives to encourage experts with disability or from ethnic backgrounds; for example, using disabled experts to host London 2012 Olympics TV coverage.

Claire Richmond, TV Producer, talent hunter and founder of www.find
atvexpert.com explains:

> The two biggest challenges facing new talent today are getting noticed
> and standing out from all the other talent and experts who want to be on
> TV. Experts and new talent have to ask themselves 'What is it about me,
> my personality, my area of expertise or the projects that I'm involved with
> and passionate about that's going to make the TV industry sit up and
> take notice of me?'

Claire set up online database www.findatvexpert.com in 2008 to bridge the gap
between professionals and programme-makers, helping TV researchers and
producers find experts for TV, radio and media. Success stories include David
McClelland, who gained his job on BBC's *Rip Off Britain* via the site, and
property expert Roger Southam, who has worked as presenter on ITV's *This
Morning*, BBC News and the BBC's *Don't Get Done Get Dom*.

More recently Claire established a sister site, www.beatvexpert.com aimed
at experts, with free online seminars, media training and advice, such as how
to prepare for a live TV interview. Categories include Science and Technology,
Home, Gardens, DIY, Fashion and Beauty, and News and Current Affairs. Claire
continues:

> There have been experts on TV as long as there have been documentaries
> and factual programmes. But what we've seen in the past twelve years is
> the rise of the expert presenter including Phil Spencer and Kirstie Allsopp
> on Channel 4's *Location, Location, Location*, Jo Frost on Channel 4's
> *Supernanny*, Neil Oliver on BBC's *Coast*, Gareth Malone on BBC's *The
> Choir* and Dr Christian Jessen on Channel 4's *Embarrassing Bodies*. The
> great news is that they come in all shapes, sizes and ages – we don't want
> all our expert contributors and expert presenters to look and sound the
> same. We want experts who challenge, shock, entertain, inspire, who
> make us look at the world in a different way. Experts who reflect the
> society we live in. Experts we can relate to – and experts we believe in.
> That's why there are more opportunities for experts on TV. But it's a
> hugely competitive market.

Your first broadcasts as an expert might be as a co-presenter, or interviewee,
but you may be so successful that the viewers or producers want more. You
could build up confidence and a profile before aiming for the main presenting
role. Research radio and television schedules to find relevant programmes you

could approach and possibly appear in. You could even generate programme ideas (see Chapter 17).

The rise of the female expert

It is a very good time to be a female expert as broadcasters are redressing the gender imbalance of interviewees. Responding to the need for more women experts on TV and radio, the BBC Academy set up several BBC Expert Women Days during 2013 in London, Salford, Scotland, Northern Ireland and Wales to create a larger pool of female contributors and presenters. More than 2,000 applicants with expertise including economics, history, science and architecture applied for the first event with 30 women initially being chosen to receive broadcast training. Many were snapped up as guests and presenters on TV and radio as the training scheme rolled out nationwide. The BBC Expert Women YouTube channel shows finalists' video applications and serves as a database of women experts.

Business presenter Colette Quartermain applied to the BBC's Expert Women and was selected for one of the training days held in Cardiff. She is now on the BBC database for expert women contributors in the Business category.

> This was an opportunity to feel exactly what it's like to be interviewed live in a TV and radio studio. The feedback from the trainers on what works and what doesn't in a live environment was really helpful, and networking with broadcast experts gave an insight into working in broadcast.

Intellectual Property Specialist and Engineer Susan Etok was also one of the successful applicants to the BBC Expert Women scheme.

> I have always had an interest in science communication and public engagement. I felt that BBC training in TV and radio would give me a good foundation in the industry. I would advise presenters to get together a showreel of their work and get their name out there; networking is key in this industry.

In 2013, The Women's Room was co-founded by feminist campaigner Caroline Criado-Perez. It's a free-to-register website for female experts; so far more than 2,500 women experts are listed on their database and once you have signed up you can be accessed by accredited media. How do you know whether to define yourself as an expert? What is the difference between expertise and experience?

The Women's Room suggests that expertise is equivalent to four to five years of doing something, whereas experience is one year of lived experience.

Also in 2013, Kirsty Walker from iNHouse Communications PR company founded www.hersay.co.uk, a database to provide resources for producers and journalists who want to use more female experts. Hersay helps to raise the profile of women experts, offering training sessions, networking events, photography and styling. The site is free for experts and journalists, searchable by keyword, specialism, region and postcode.

What advice does Claire Richmond have for experts wanting to break in to the marketplace?

- ❏ Have the training, qualifications and experience to prove that you're an expert in your field.
- ❏ Be passionate about what you do, in your meetings with TV production companies and on camera.
- ❏ Watch TV. Find out who's making programmes in your area of expertise, which experts they're using and what makes you different.
- ❏ Try and catch the eye of a TV Producer. When producers are on the hunt for talent, they cast their nets widely. So if you've got a book in you, write it. When I was series producing BBC's *Changing Rooms* I always kept an eye out for new interior design books to see which new designers were coming through, and if I liked them, I'd track them down and invite them in for a screen test.
- ❏ Give presentations at events and exhibitions; try and get quoted in newspaper articles and magazines and make sure you're Google-able. If a researcher or development producer hears one of your presentations or reads about you in the press and likes what they see, they'll research to find out more.
- ❏ Make sure you're on the list of experts who are happy to be contacted. You'll only get a call from a TV production company if they know you exist. It's as simple as that. So the more ways you can be seen, heard, read about and found, the better.

Marketing materials

Marketing materials define what makes you different, and employable – they include your CV, headshots, showreel, website, blog, business cards, covering letters and anything you use for self-promotion. These are not set in stone, as your experience, skills and appearance change over time. Once you know your

USP and what you have to offer, you can generate marketing materials with confidence, focus and credibility.

In general, don't mix genres or the viewer will get confused. A website or reel that combines a musical instrument show and tell with a hard factual interview creates a confusing message – are you a children's presenter or a political analyst? That said, once you are established it's very acceptable, for example, for news readers to present other genres such as factual entertainment or quiz shows and very often regional presenters find themselves presenting a range of programmes.

New presenters can fall into the trap of feeling that they do not have enough information for their biography, and include an eclectic mix of skills that detract from the main message – if you are an expert nutritionist it is not necessary to include grade 5 piano or that you enjoy ice-skating in your spare time. CVs that contain too much information spread over several pages can leave the reader feeling that the applicant is incapable of sorting out the relevant facts from the less important ones. A favourite photograph of you on the beach may not set up the right tone if you are seeking work in the industry as a corporate presenter – get professional headshots that work for you, not against you.

CV

According to Cindy Dean, Senior Editorial Assistant at *Spotlight*:

> Your CV should show your skills, training and experience and a pho-tograph of yourself. If you are applying for presenting roles, try to keep your experience to presenting, unless you feel the experience gained could strengthen your profile. Most casting professionals prefer to see you as a focused presenter rather than a jack of all trades.

Create a CV that a busy producer or agent can speed read: punchy, to the point, up-to-date. If you lack credits then include transferable skills from previous employment or life skills. Short of CV material? Add a statement of your intentions and aims, or a bit about you as a person. If you are an actor used to including your shoe and hat size, forget it! Presenters rarely get offered a wardrobe department, they wear their own clothes. If you have several years of experience in another area, anything from finance to dance, then include a summary of your achievements and highlights, rather than listing every job – even if those contracts meant a lot to you at the time. Put yourself in the producer's or agent's position, and only include what they really need to know.

Darsh Gajjar, an Employability Adviser working in higher education says: 'In a good CV, the key selling points of the individual can be picked out by the reader in 15 seconds. A good CV does not make the reader work to pick out key information, especially not busy readers who get umpteen CVs on a regular basis.'

Update your marketing materials regularly, tailor the content to the job you are applying for, re-edit your reel and reshoot your headshots. Think through how your CV matches the job specification and adapt as necessary; you might need to tweak your CV for each job to emphasise different experiences or skills.

According to John Byrne, Entertainment Industry Career Adviser at *The Stage* newspaper: 'A good CV is one that gives me the relevant information I need to decide whether or not the presenter is worth considering for a particular job . . . therefore a good CV differs for each individual job it is submitted to.'

Templates for CVs are varied, but avoid starting with your education, as that will give the impression that you have done nothing since leaving school. Instead start with strong achievements to keep the reader interested, and if you think your age is against you, remove dates.

I came across a would-be children's presenter who wrote her CV by hand and rolled it up into a Christmas cracker before sending it out to potential employers in December. You can keep it simple or think outside the box, but one rule I would apply is brevity – be ruthless.

Prospects, the UK's official graduate careers website has information on CVs, covering letters and interviews plus useful examples of different types of CV such as chronological, academic and skills-based – the latter is best for presenters.

Some agents are not particularly interested in your CV, placing much more emphasis on your reel, your plans, your experience and your following. Andrew Wilson, Founder of Cloud9 Management Ltd talent agency says, 'I don't care what you've done, I want to know what you're going to do tomorrow.'

Headshots

Invest in professional headshots – you'll need these to subscribe to *Spotlight Presenters*, to upload to job promotion websites, to add to your CV or your website. Take a look at *Spotlight Presenters* to see the styles and range of photos. *Spotlight Presenters* advises a colour headshot that reveals your personality. It may sound corny but if you are a TV chef you can be photographed in a kitchen wearing an apron, as this look immediately communicates what genre of

presenting you work in. If you are interested in presenting in finance, news, factual, business, etc., your appearance should denote authority, trustworthiness and sincerity. Check your clothes, accessories, makeup and hair to see if they give out the right signals. A professional photographer can assist in creating the appropriate image and selecting the best shots.

Should presenters have colour or black-and-white photos? Definitely colour. There are black-and-white pictures in *Spotlight Presenters* as some actors use the same image for the main *Spotlight* and *Spotlight Presenters* directories. Traditionally photos of actors in the main *Spotlight* are monochrome and neutral in expression, it's a classic cinematographic look that enables a casting director to imagine an actor in a range of roles. However, presenters are themselves, so their image should not be open to interpretation. Aim for a warm and friendly look, head and shoulders in the frame, facing square on to the lens (rather than 'this is my best side').

There are lists of photographers in *Contacts* published by *Spotlight*. You can also research which *Spotlight* photos appeal to you, and contact the photographer credited for the work. Some photographers offer deals such as interior and exterior, all contact sheets provided, all photos included in the price, so check out websites to compare prices and services.

Sarah Jane Cass, Senior Talent Agent at Somethin' Else, advises: 'Think about what you'd like the images to say about you. Do not use low resolution images. Don't use personal photos from Facebook as your headshot. Images should represent your personality, so not too posed or sexy modelling images if, for example, you want to be a children's presenter.'

Reel

What are agents looking for in a reel?

'Create a targeted showreel on the area of presenting you'd like to go into,' continues Sarah Jane Cass. 'No more than three or four minutes, with a mix of strong pieces to camera showing interaction, such as interview, with some walking and talking. Have fun with it, relax, smile and show your personality.'

We are witnessing the rise of the self-made reel as shooting video becomes more commonplace on phones, stills cameras and affordable camcorders. Even the BBC Expert Women scheme accepted video applications shot on mobile phones. There are advantages to shooting and editing your own reel: you're in charge of your own footage, you can record an unlimited number of rehearsals and takes, react to opportunities quickly and update and shoot unique footage in locations of your choice. However, there are risks including an unprofessional

look, with potential sound, lighting, framing, focus and editing issues. If budget permits you could consider using a bespoke showreel service or hire professionals to shoot an individual reel with you. There is more information in Part Four of this book.

Michael Joyce, Founder of Michael Joyce Management, represents presenters Gillian McKeith, Dr Nirdosh and Wendy Turner Webster. What is he looking for in a reel?

> Keep it real. Showcase your strengths. One presenter made a reel based on his love of alternative music, went to gigs and interviewed the artists. He edited the show himself online and he really stuck out for me. What makes one presenter stand out from the crowd? When I watch a link and immediately start thinking about where they could be placed or pushed to.

Increasingly presenters who I've trained use the DIY reel route, to display personal passion and commitment and create a reel unique to them.

Spotlight's Cindy Dean agrees that reels should be short, and that they can be homemade:

> The first 20 seconds are vital, as agents and casting professionals rarely watch them all the way through. And keep it short, two to three minutes will be fine. It does not have to be professionally shot, you can get a friend to help you, but remember there are many showreels being sent out and you want yours to stand out from the rest. Keep your showreel up to date so that it can be sent out at short notice.

One tip is to store your reel digitally on a system such as Google Cloud so it is easily accessible when you want to show it to someone quickly, and reliably backed up and archived.

Andrew Wilson, Founder of talent agency Cloud9 Management Ltd, suggests: 'It's all about show, don't tell. Be doing something, not talking about it, but if you must talk about it then be doing it when you're talking about it. Be endearing, be funny, be passionate, be relaxed, belong.'

What about the showreel for the expert presenter? Claire Richmond offers the following tips:

❑ You're pitching yourself and your expertise. Keep the shot tight (chest up) and clean (no distracting posters, etc., in the background) so the focus is 100% on you.

❑ Keep the eye contact / energy / smile throughout. Talk to whoever's watching your pitch (the researcher, producer, commissioner) as you would to a friend. Don't put on a formal voice.

❑ Include the basic information: name, speciality / area of expertise (and how long you've been an expert for), plus a fascinating fact about your expertise that you're particularly keen on and the reasons why.

❑ If you don't grab their attention in the first few seconds, they'll switch off. So think of different ways of starting – maybe some mind-boggling statistic, for example.

Website

Having your own website is a one-stop shop window to host your biography, CV, video, photos, links, blog, etc. At its simplest it's a virtual business card, at its best it's a responsive and evolving record of your activities and career to date. Off-the-shelf web templates, links to social media and your videos can be set up relatively easily, or you could employ a designer – see Chapter 21 for further details.

David McClelland, technology expert and TV presenter reveals:

> By far the single most valuable resource for finding work as a technology presenter has been my website. I don't have a particularly flashy website, just a free WordPress blog decorated with a free theme. However, I do keep it up-to-date with details of the work I'm doing, clippings from articles I write and videos that I appear in. By writing fairly regularly about technology, the site's search engine optimisation is very good.
>
> I also have some free website statistics software installed, which lets me see the search terms people are using when they come to my site, as well as which pages they visit.

David noticed that somebody from a television production company had been repeatedly visiting his website. He followed this up with an email to the production company and the following day the development team gave him a call. David adds: 'The website costs me almost nothing to run. The most expensive part is your time in keeping it up-to-date with what you're up to.'

Del Brown – live director / vision mixer whose credits include QVC, The Jewellery Channel and Gems TV is always on the lookout for shopping presenter talent. He agrees that a website with embedded video or links to reels, recent photos and contact details is a must.

I'm most impressed by simple layouts and up-to-date information. I quickly lose interest when viewing websites that are difficult to navigate, dead links where websites have been removed or not renewed, or when I'm looking at photographs of presenters that were taken about five years ago and their most recent work is dated 2008.

Digital marketing

Paul Fryer, a Digital Marketing Manager working in higher education, says there has been a change in marketing trends.

> In the past year there has been a great shift in marketing budgets to concentrate on digital marketing as opposed to traditional methods. One big influence on this has been the rise of mobile technology, as the ease in which data can be accessed from anywhere is increasing. People are spending more time online than ever before, and engaging in different ways. There is a definite shift towards 'second screen experiences', where people are browsing on their phones and tablets while simultaneously watching TV.

The rise of analytics software enables you to target certain demographics and monitor campaigns. Twitter has also become the breaking news feed and the main way for people to communicate internationally. So how can you take advantage of these trends and generate some noise?

'Increasing your profile is so important, as you need to build your brand, audience and have your own digital footprint,' advises Somethin' Else's Sarah Jane Cass. 'Keep consistency with your usernames/blog/YouTube channels so it's all under the same name. Get signed up with Google +, blog sites like Tumblr, WordPress, social channels like Twitter, Instagram and LinkedIn, and keep them up-to-date with fresh content. Creating your own website is a great way of having one central home for all your content.'

Paul Fryer agrees: 'Set up various social media accounts (a blog, Twitter, Facebook and YouTube channel) and frequently produce interesting media rich content. By being on a number of social media accounts and managing them well you will improve the chances of people finding you on Google. You also can use Twitter to network with other people in the industry, make contacts and be the first to hear about industry opportunities.'

Cindy Dean advises keeping it professional and talking positively about the industry and what you're up to (as long as it's not a confidential audition!).

'Where once you'd be putting up posters and handing out flyers, you can now reach the right audience with simply a retweet from an influential Twitter account. They can also see your personality through Twitter or YouTube, so be yourself and use them to stand out from the crowd.'

To keep up-to-date with changes in social media, participate in discussions, read blogs and the online press. 'Video is becoming increasingly influential online with short clips being pushed through services such as Vine, Keek and Instagram,' says Paul Fryer. 'Short videos are easy to access on mobiles and people are happy to engage with it this way. If you do have social media accounts or a website, monitor the hits and engagement. Monitor what content works best for the audience you are trying to attract and tailor it accordingly.'

Case study: Kerrie Newton, Fashion Presenter

Model, stylist and presenter Kerrie Newton is busy building her brand, and recently had a successful audition with QVC.

How did you decide which area to pursue?
I am a qualified massage therapist and beautician. After winning the Star Spa presenter Search 2012, I was certain that beauty expert was the best way to brand myself. However I was no longer administering treatments and hadn't done so for a few years. I love fashion, it's part of my life and a hugely significant part of my personality and branding, so I decided to go with fashion, gaining credibility by completing a styling course, starting a blog and auditioning to be a fashion presenter on QVC.

How do you build up your brand and profile?
Find stories, people, anything that interests you and talk about it. Make a film and share it. I created short fashion videos with a funny twist, making fashion styling edgy and fun. I hosted fashion events for free, rebranded my website and created a Facebook page, which has been so important in getting my name out there and crucially connecting with other fashion creatives and making those invaluable contacts.

How do you use Twitter?
Twitter has increased my profile greatly. Sometimes people ask me 'what do you tweet about?' I recommend keeping things light and a little

personal, as Twitter is about showing your human side and making others connect with you on a more personal level. It's a great way to follow presenters and professionals you admire and want to work with. My favourite fashion stylist and presenter Brix Smith Start began following me after I tweeted about her on the TLC show *Shopaholic Showdown!* Naomi Campbell, Erin O'Connor and Caroline Winberg also retweeted and responded to my comments about Sky's *The Face*. These connections raise your credibility and show your name, ideas and image to all their followers. Clear branding breeds credibility, so it is essential for a new presenter trying to stand out and be seen. Let your work do the talking and share it!

How do you use YouTube?
New presenters must have a YouTube page and keep it updated. As you film, develop your relationship with the camera and your skills and knowledge will soar. Now production companies scour the Internet for new personalities, if your channel is popular you could find yourself being approached very quickly.

Networking

All experts agree on the importance of networking. Del Brown advises: 'As soon as you've done any job, search for the people you worked with on LinkedIn. Exchange business cards, extract email addresses from call sheets. All these things help to get you remembered and also put you in a good position should work arise as people can easily find your details.'

Matthew Tosh is a science broadcaster, writer, pyrotechnician and education consultant whose clients include National Science Learning Centre, European Space Agency, Met Office, ITV and BBC. Matthew uses real-life and online networking to create new contacts and work. He suggests the following rules:

❏ Selectively tweet about your work, tailoring the content so it is relevant to the followers you want to engage.
❏ Publish pictures of any interesting and unusual aspects of your work. It really gets people interested and talking.
❏ Have your own website, listing credits, photos and showreel.
❏ Always carry business cards.

❏ Try to get your photos and professional profile on local and regional media network websites, not just national ones so people know you are a local expert who can be called upon too.

Make sure your communications are in order. As a freelancer himself, Del Brown knows how important it is to be reached easily and rapidly. In today's market, employers expect you to react very quickly to a job alert.

> When I am looking for presenters to work on my live director / vision mixer training short courses I send a mass email to more than 30 or 40 presenters. Within minutes I get the first wave of 'postmaster undelivered' because presenters have changed their email addresses, or they never access their email accounts and their inbox is full. Within about 30 minutes, I get the second wave of emails from presenters either saying yes they are available or no they are not. Within about an hour, I'm clicking on websites or researching presenters to familiarise myself with their work.

To do list

❏ Decide your USP.
❏ Research TV and radio – could you be an interviewee, an expert?
❏ Update CV.
❏ Invest in headshots.
❏ Create / update reel.
❏ Create / update website.
❏ Explore digital marketing.
❏ Network.

Click, read, discover

www.spotlight.com
www.findatvexpert.com
www.beatvexpert.com
www.youtube.com / bbcexpertwomen
http:/ / thewomensroom.org.uk
www.hersay.co.uk
www.wftv.org.uk – Women in Film and TV
http:/ / creativediversitynetwork.com
www.twitter.com

US

www.backstage.com
www.onlocationcasting.us
www.hollywoodsouthcasting.com
www.dmoz.org/Arts/Performing_Arts/Acting/Actors_and_Actresses/
Databases_and_Casting_Services – directory of casting and audition
databases in the US

CV, headshots, reel, website

http://prospects.ac.uk – for CV, covering letter and interview advice

Contacts, published by Spotlight lists photographers

Wolfe, Kathryn. *So You Want to be a TV Presenter?* London: Nick Hern
Books, 2010 – how to create a TV presenting CV and what to include on a
showreel.
http://wordpress.com – set up a blog for free, embed your video in your
blog

Networking

Keep up to date by reading:

www.theguardian.com/media
www.broadcastnow.co.uk
www.digitalspy.co.uk
www.musicweek.com
http://radiotoday.co.uk
www.thestage.co.uk

Digital marketing

www.econsultancy.com – for all things digital marketing, blog has excellent
real world examples of successful online campaigns.

www.cim.co.uk or www.theidm.com – both offer qualifications in digital marketing to give a great understanding of the principles of running a successful campaign.

Google offer certification in Pay Per Click and Analytics, which is invaluable for testing the impact of a campaign.

four
Career Check

How can you shape your career? Are you where you would like to be, if not how do you get there? Should you be going for different types of jobs? Do you need an agent and does an agent need you? This chapter provides unique insights from industry experts on how to manage your career.

Finding an Agent

Many agents are listed in *Contacts* published by *Spotlight* and *The Knowledge* online. Agency websites reveal what kinds of presenters they take on, some agencies specialise and others represent a mix of presenters. For example, Coalition Talent, Wise Buddah, Insanity and Somethin' Else represent several leading Radio DJs and fresh TV entertainment talent, so if music is your passion, or you are a DJ with a following, then research these agencies. *Spotlight's* website, www.spotlight.com, has a free, simple to use search tool that will give you the name of a presenter's agency, if the presenter is a *Spotlight* member. As ever, some agencies are more approachable than others, and you may need to be persistent to get past the gatekeepers.

Sarah Jane Cass, Senior Talent Agent at Somethin' Else, advises:

> When you're looking for an agent, look at the current roster list. Who do they look after, where would you sit within that agency, would you get lost or do you stand out? It's important to meet a range of different agencies and find an agent that you get on well with, you feel comfortable to call and trust. You may end up speaking to them more than your family members each week.

When you are on an agent's books you still need to network and be proactive about finding and creating work opportunities – your career is a joint effort much of the time. It is not just the agency that matters, it is important to find the right agent within the agency, someone you click with.

Cindy Dean, Senior Editorial Assistant at *Spotlight*, agrees: 'Make sure you find an Agent that suits you. Don't stop self-promoting once you have gained representation – you have to work hard yourself if you really want to succeed.'

Science presenter Fran Scott has been represented by Andrew Wilson at Cloud9 Management Ltd since 2009:

> I set about producing a showreel and contacting agents who I thought were appropriate for me. Fortunately (or unfortunately depending on your outlook), the feedback was encouraging, so I thought I'd pursue, and I found myself a brilliant agent. He was friendly, but honest, and had a few carefully selected clients, perfect for a newbie as I knew I'd need a lot of attention to hone my skills, and see where I would fit best.

Agents may say their books are full as a polite way of rejection but that could mean they have too many presenters like you and will not be able to devote enough time to promoting your career, so you may need to shop around.

Andrew Wilson advises: 'I always recommend meeting more than one agency, everyone is different and you need to find the one that fits you. Remember it's a weird business/personal relationship you have with an agent, so choose the one you trust to work hardest on your behalf but also the one you feel you can open up to, sometimes you need to have very intimate conversations.'

How to contact an Agent

Michael Joyce, Founder of Michael Joyce Management, says: 'An email with a letter, photo and an online link is always the quickest way to get immediate attention.'

Find out how an agent wants to be contacted and what materials they require, and in what format. See if the information you need is on their website first as it will help you to get off on the right foot. Check if the agency represents presenters, as many agents are for actors only. Some agencies represent talent working in more than area, such as voiceovers and presenting, or modelling and presenting, some represent actors who also present.

Sarah Jane Cass offers the following tips:

❏ Don't approach an agent until you're ready with your showreel, you've got experience and you feel you've done everything you can but need extra help.

❏ Don't send large video attachments or images as they will fill my inbox.

❏ Put your reel on Vimeo on a private account or, if you have a YouTube channel / website, put this link in the main body of the email with a short biography / photo.

❏ If you have a large YouTube / Twitter following, state within the email how many followers / subscribers you have.

❏ I'm very active on Twitter @SarahJaneCass so I get approached with links to presenters' websites or through our Somethin' Else company email.

Agents are busy people, they receive dozens of emails and letters in their postbag every week from hopeful actors, presenters and performers. Make their lives a bit easier. Andrew Wilson says:

> It's remarkably simple and yet so rarely do people do it! Start by writing 'Dear Andrew' and drop other subtle hints that show you've read my website and know who I am. Making the approach as personable as possible is time-consuming but will ultimately deliver better results. Emails with links to video material are the best. Get right to the point, say who you are, what your credentials are, what you want to do and a link to a killer showreel. Job done.

Do you need an Agent?

You do not need an agent at the start of your career, as it is easy to find auditions and pick up work if you have the right skills. Some presenters work steadily for many years building up their track record and portfolio without using an agent.

But you may want to break into more mainstream work, enlarge your pool of contacts and be introduced to high-profile production companies. Are you aware of the going rates? Do you understand contracts? Do you have your ear to the ground when it comes to productions that are being planned? An agent will be able to open doors, set up meetings with producers, negotiate on your behalf, check your contract and should have the inside knowledge on what opportunities are coming up. So, yes, an agent can help your career to take off and put it on a more professional footing.

Sarah Jane Cass confirms: 'An agent will only represent you when they feel they can get you to the next level.'

Technology presenter David McClelland is represented by Hilary Knight Management:

> I have an agent who is worth her weight in gold. She has working and established relationships with producers and production companies, as well as terrific skills in negotiating fees and contracts. She knows going rates for particular kinds of work and handles a lot of the paperwork, invoicing, chasing of invoices and telephone calls that I simply don't have the time to manage. And, of course, she has a website of her own that serves as another shopfront for her presenters.

If you need advice on rates of pay, contact Equity, the UK trade union for professional performers and creative practitioners. They have recorded media agreements covering all types of artists working on productions including the BBC, ITV, BSkyB, independent film and television, Internet, non-broadcast film or video. Equity does not use the term 'presenter' in their agreements, as it considers the term 'artist' to include presenters.

Equity run a subscription-only Industry Information Service with new rate cards and agreements negotiated with TV, media and theatre companies with advice on contracts, tax and insurance and free access to legal services for members.

Andrew Wilson adds: 'Once you get a paying gig I would, as an agent, highly recommend you get an agent! Budgets are tight, people are unscrupulous, you need someone looking after your best interests and making sure contracts are watertight. It's once you've got something potentially on the table that an agent can help you get a good deal, develop you and your contacts.'

Some performers have more than one agent, handling work in voiceover, acting, modelling and commercials. An organised diary is needed to avoid double bookings! How does this work? Nicole Harvey, actor, voiceover artist, presenter and model has four different agents, not just in UK. 'I have one UK acting agent who also receives presenting breakdowns, a UK model agent with a different client base, a UK voiceover agent, and a US voiceover agent. I am vigilant about emailing any non-availability so nobody wastes their time.'

Does an Agent need you?

What is an agent looking for? What makes one presenter stand out from the crowd? Is it important to have experience, or is potential enough? Sarah Jane Cass says:

> We represent a range of different presenters, so it depends what the market is looking for at the moment and whom we already represent. When I watch showreels they need to grab my attention and have to excite me. What type of presenting do they do, where would they sit within the industry? Are they a leader in their field? I research talent online and look at their social media influence/conversations. Be careful, this can backfire and if you wouldn't say it out loud, don't say it online!

Andrew Wilson's last few signings are a nanny with 20 years' experience and a unique style, a character from Channel 4's *Made In Chelsea*, the son and heir of a notorious Lord, the youngest person to row the Indian Ocean and a young female YouTuber with lots of subscribers and a unique take on life.

'Although they are "presenters" of a sort, they are actually "personalities" and that's what I'm looking for,' says Andrew. 'People with charm and credentials. If you have a doctorate or an MBE you go to the top of the pile, if you have a unique worldview, all the better. I'm not looking for presenters-for-hire. Comedians are the new presenters, so if you want to be a presenter, get on Channel 4's *8 Out of 10 Cats*.'

Should you go for a management company or agent? What is the difference between an agent and a manager? Michael Joyce says:

> Everyone works differently – some agents sit at a desk and email and take calls. At MJM we actively go out and about to meet broadcasters and development teams to find out what is going on and being commissioned – then we can start pushing the right clients in that direction. Being proactive and not totally reactive is the key for me. A manager can be someone who does everything for you – an agent can just book you into a job. I like to offer what I call the 'one stop shop' and have better control that way over a presenter's career.

In this age of the specialist presenter is it best to go with a specialist agency, or be the expert presenter in an agency that is more general? The final word to Michael Joyce: 'Both – but I think each party knows when the fit is right and no agent or talent wants to have, or be just a face on a client list.'

To do list

- ❑ Research agency websites.
- ❑ Approach agents who might be right for you.

Click, read, discover

www.theknowledgeonline.com – lists crews, services, production companies and agents, free to use

www.kftv.com – lists international production companies, services, crews and agents, free to use

www.theproductionguide.co.uk/directoryhome – directory for film, TV and broadcast industries, lists agents, free to use

Contacts, published by *Spotlight*, lists agents and personal managers

www.equity.org.uk/home – UK trade union for professional performers

Follow casting sites on Twitter for industry news, jobs and networking, such as:

@spotlightUK
@mediaguardian
@TheStage
@Broadcastnow
@dearjohnbyrne

Part Two
On the Case

This section contains case studies from presenters in a wide variety of genres who have created and seized opportunities, generated some luck and launched their own TV careers. Producers and production teams across different areas of TV give their insight to help you shortcut some decisions. The thread running through these chapters is that expertise opens doors; you can build up your brand and develop your own career.

five
Children's Presenting

Children's programming is a very attractive genre, especially if you enjoy working with children. Children's presenters often have backgrounds in acting, character voices, puppeteering, animatronics, physical theatre, mask work and 'skin' work (acting inside a costume) or they may run children's events such as drama and dance classes or children's parties.

Children's TV production has suffered from cutbacks, changes in advertising regulations and scheduling, but highly successful programmes are still being made by a variety of top UK production companies, mostly for the BBC. The multi-award-winning BBC children's channels are shown around the world, broadcasting programmes for older viewers on CBBC, with 1.8 million children viewing each week in the UK. On the air daily, CBBC shows a mix of drama, entertainment, factual and comedy and live presentation aimed at six- to 12-year-olds.

CBeebies, for the pre-school age range, has a rich schedule including entertainment, drama, comedy, factual and live presentation links. The output of live action and animation educates and entertains – the BBC's aim is learning through play. Like CBBC, programmes are also available on mobile apps, iPlayer and simulcast on the CBeebies website. Although the BBC has a very active Children's Department, broadcasting slots are limited and highly competitive.

The BBC also offers radio programming for children – CBeebies Radio is a web-based radio station for pre-school listeners, with podcasts that can be downloaded. It features games, stories, and listening activities with characters and presenters from the CBeebies channel.

Children's radio is not restricted to CBeebies. Fun Kids Radio is available in London and the south east, aimed at children between four and nine years old.

Currently there are seven presenters who entertain younger viewers with games, competitions, songs and stories, with videos on their YouTube channel.

CITV, short for Children's ITV, has less original programming, with the schedule mostly playing repeats and acquisitions. There is little produced for Channel 4 in the children's genre.

Milkshake! on Channel 5 has been successfully broadcasting since 1997. It has a small team of presenters who appear on the website and in-vision continuity. One of the most famous former *Milkshake!* presenters is Konnie Huq who went on to become the longest serving female *Blue Peter* presenter on the BBC.

Virgin Media hosts around 21 children's channels, and on Sky there are more than 30, the most well-known being the Disney channels, Nickelodeon channels, Kix and Pop channels.

Key skills

Gemma Hunt is a popular BBC TV children's presenter whose CBBC credits include *Xchange*, *Barney's Barrier Reef* and *Bamzooki* and more recently the hugely popular pirate game show *Swashbuckle* for CBeebies. What makes a successful children's TV presenter in Gemma's view?

> A successful children's TV presenter needs to be 'real', children can see through you if you're not sincere. Showing a genuine interest and listening to them rather than talking down to or patronising children will give you more likeability. And it helps if you really do like children!

Children's Producer Alison Ray, whose credits include CBeebies' *Presentation* and *Tweenies* and CITV's *Jim Jam and Sunny*, says the key skills that a children's presenter should possess are 'an ability to communicate on a basic level but without dumbing down. An older brother or sister approach, talking to children rather than at them and talking straight into the lens of the camera as though they were in the room with the viewer.'

Sharon Miller directed children's TV at the BBC for five years, working on dramas, multi-camera presenter-led studio programmes, location series and documentaries with presenters. Sharon now writes for children's TV, with credits including five *Thomas & Friends* movies, and agrees that the key skills needed to be a children's presenter are:

> Confidence, friendliness, fun, ease, spontaneity, relaxation and focus. The child at home – the audience – wants to enjoy being with the presenter,

much in the way they would enjoy being with an older cousin. They want to be amused, entertained, engaged and informed. They sense stress or awkwardness – or any kind of overt effort to be kid-friendly.

Looking for work

Apart from the channels that create children's content in-house there are specialised independent production companies who produce programmes for broadcasters. View and research TV programmes noting the production companies on the end credits – key names such as Executive Producer, Producer, Series Editor – then contact them direct with a well-written email of introduction and a link to your reel and website. *Blue Peter*, running on UK television since 1958, is an example of a programme produced in-house at the BBC, whereas if you check the end credits of *Richard Hammond's Blast Lab* you will see it was produced by an independent production company, September Films, so you would contact that company direct.

Production companies often merge and key personnel move on, so keeping up with who is doing what can be a full-time job! This is where an agent can be incredibly useful, setting up meetings with production companies and keeping tabs on who is where.

What advice does Gemma Hunt have for new presenters trying to break in to children's programming?

> Spend as much time with the children in the age group that you want to work with as possible so that you can understand how to talk to and interact with them face-to-face, then transfer these skills to the camera, talking to the camera as if speaking to an individual child. Offer to help host a children's party, lead a youth group / Sunday school or organise a children's showcase to give yourself experience in talking publicly to children. Get these experiences filmed and cut together a showreel and add in any extra pieces to camera that you can get, then upload it to YouTube and send the link to agents / producers.

Darrall Macqueen Ltd is an award-winning UK children's TV production company whose list of top shows includes *Smile*, *Topsy and Tim*, and *Baby Jake*. How does Executive Producer Billy Macqueen find and select children's presenters?

> We ask everywhere from small local papers to the major social media networks – Facebook, YouTube and Twitter. Agents are good, schools

are good, but the right person can come from anywhere. Have most of them had some performance experience for example at school, youth theatre or dance? Yes. The big thing with younger presenters is whether they can cope with the boredom of the recording day, it isn't all camera action and makeup time. There are hours of waiting around.

Is age important – what about the older presenter in children's programmes? While you probably need to be young for straight-to-camera presentation and continuity links between programmes, some productions employ slightly more mature presenters for a maternal/paternal style that can be reassuring for the younger viewer. There are openings for older (such as ex-teacher) presenters, for example, Tom Pringle AKA Dr Bunhead presented Sky One's science series *Brainiac: Science Abuse* for several years. Tom Pringle is an expert science demonstrator and trained teacher with a degree in Chemistry and two post-graduate science qualifications. Whatever your age, it's important to get the tone and use of language right for the viewer, adhering to broadcaster guidelines on what is and is not appropriate for the target age range.

Reels, screen tests, auditions

How are presenters chosen, by a reel alone? Does the process include an interview? Is there a screen test? Are they mostly actors? Steve Cannon – who has 20 years' experience in pre-school programming as Producer, Director, Script Editor and Writer, on shows including the award-winning *Justin's House* and *Razzledazzle* for CBeebies – says:

> I and most of the colleagues I have worked with always want to screen test presenter talent, no matter what their experience. Showreels help, especially if they are sent after contact with an agent or the person concerned, but the needs of each show, particularly in pre-school, mean that it is very rare that a reel will give a comprehensive view of the talent we require.

Has Steve Cannon used presenters who have not presented before, and if so, how has that worked out? 'It is not unusual to work with talent who are new to presenting. If the casting process has been sufficiently well organised, then the outcomes are almost always great.'

Sharon Miller agrees:

I am always keen to use new talent. The difficulty is getting new presenters past producers. Producers tend to be nervous about hiring someone with no experience. However, this can be overcome. The reel has to be very good and the studio audition has to be a home run. It happens. If you're good – very good – producers are keen to discover the next Dick and Dom . . .

Look out for opportunities. In 2013 *Blue Peter* launched a search for a new presenter called *You Decide!* More than 20,000 hopefuls applied and the winner was Lindsey Russell who had just graduated from Bristol University. Presenter Kerry Boyne got down to the final ten and describes her experience:

> There were different stages to the audition process after the video entry, including 30 minutes to learn an opening script of a *Blue Peter* show and only two chances to perform this to camera. Then 20 minutes to prepare an interview with a child star dancer. There were certain questions that had to be asked within that interview, in addition to getting the child to demonstrate a move and giving information about an upcoming CBBC dance programme. There was so much to think about and we only had one chance! We had to do a make with another contestant. We were given 15 minutes to learn the step-by-step instructions, delegate between us who was going to read what, be capable of demonstrating how to make it properly using all the props whilst giving particular science facts along the way – not forgetting bags of personality.

Typical pitfalls when presenting for children are talking down to your audience, being patronising and playing the part of a presenter rather than being yourself. So as well as having presenting skills, it is important to get the tone right – it helps to really understand your target audience. Sharon Miller agrees:

> Cookie-cutter kids' presenter reels – don't cut it. They need to be able to make and do things with confidence and calmness, while laughing at themselves or at whatever might happen. They have to be themselves and not 'put on' what they think is a presenter persona. If stand-up comedy isn't your thing – don't do it. Don't do anything you're not comfortable being.

Gemma Hunt adds:

> It's best to use a variety of content in your showreel and show off your individuality rather than impersonating someone else. Showcase any

skills or interests you have and don't shout! Just because you're trying to show high energy for entertaining children, you don't have to shout to get their attention, work at using your eyes to show life and sincerity.

Upload your reel, target the shows you would like to work on and send the links to key personnel on the show with an enthusiastic covering letter.

What does Steve Cannon like to see on a children's presenter showreel?

There are many elements which box-tick: natural presentation; individuality (so many are stock, unimaginative smiles); the ability to make the subject matter stimulating; pitching to the right age range (pre-school and 7–12 presenting styles *do* differ, so the reel ought to be clear which sections suit which market); not being patronising; the ability to connect with the viewer.

There is no need to spend a fortune on your reel – true talent will shine through if you do a piece to camera in your house or garden shot on your phone. Billy Macqueen confirms:

You can tell with a 90-second piece to camera with someone talking about themselves and why they think they would be good. Don't go and get a 15-minute, heavily edited showreel at huge expense. You can shoot a good showreel on an iPhone. Just ensure the sound is as good as the picture. With YouTube, good show reels are common and uploaded every minute, but it does mean a flood of potential presenters.

Moving on

It is competitive to get into children's presenting, so only go for it if you are really passionate about it; don't see it as a way in to another genre. Although some presenters spend their entire career in children's TV, some feel that once they have made their mark it is time to move on. Is it true that once a children's presenter always a children's presenter? There are so many presenters that have moved from children's to other genres, that this can't be true – Helen Skelton presented *Blue Peter* for five years before moving on to BT Sport as a football presenter. BT Sport presenter Jake Humphrey previously presented on CBBC programmes *Bamzooki* and *Sportsround*. Konnie Huq, with more than a decade of *Blue Peter* presenting behind her, went on to ITV2's *The Xtra Factor*. Other famous faces who moved from children's to entertainment include

Phillip Schofield, Chris Tarrant, Holly Willoughby, Fearne Cotton, and Ant and Dec.

Case study: Michael Absalom, TV Presenter

During Michael's CBBC years (2002–2006) he hosted *Best of Friends*, *Xchange* and *Sportsround*. He has now moved to sports commentating for hockey, skiing and Formula 1.

How did you break in as a TV presenter?
I started by doing one of those courses they say you shouldn't waste your money on when I was 20 years old. I came away with a showreel at the end of the two-day course, which I made 100 copies of. I then sent this off to as many people within kids' TV as possible. One copy landed on an agent's desk (Jo Carlton at Unique Management, which was owned by Noel Edmonds at the time). They got me my first screen test with CBBC, after which I was offered a contract to be their new runner/presenter in 2002! From there I took every opportunity going.

What advice would you give to new presenters trying to break in to children's programming today?
Be yourself. Children's TV is a lot of fun so it's important to enjoy yourself. This shines through on camera as well, if you are genuinely having fun. If you truly believe you are good enough to do the job then work your socks off to prove it. You will face a lot of rejection along the way, but take it on the chin! It just means someone else was better than you on the day or for that particular role.

How did you make the move from children's presenting to sports broadcasting?
Getting your first job on TV is hard enough, but moving on to the next job is ten times harder. I focused on moving into an area I was passionate about, sport. Having played hockey to Junior England standard, I pursued the commentary side of things, which has led to other sports broadcasting opportunities. Networking is key to your success if you're to make the transition smoothly. Generate your own ideas and make them happen using whatever contacts you have built up over the years.

Do you feel children's presenters get pigeonholed?
Take it as a given – you will be pigeonholed. But never underestimate the skills you have learnt, especially if you have done live telly. The skills you develop while working on kids' TV are all transferable. You will just meet lots of people that can't see that straight away. It's your job to prove this to them.

What does the future hold?

The way forward is to do your own broadcasting online and, if successful, hook up with companies and funding. The traditional mainstream type of presenting is just a small part of what is going on. See Chapter 21 for examples of young personalities who have gained millions of subscribers by creating their own videos. Sharon Miller adds:

> Working online is, above everything else, the way new presenters should go. It is so easy to write, record and upload yourself presenting a show. It is by far the best way to sell and introduce yourself. Producers will watch things on YouTube whereas they can let a DVD lie around for months if not years. Make your own show for the Internet. It costs next to nothing and is the way all programming is going. Programmes now are multi-platform. So to look to CITV, CBBC or other channels as the only route in is not to be where TV is now. Online there are a lot of possibilities – so the future is good.

To do list

- ❏ View children's programmes and presenters on TV and online.
- ❏ Understand the differences between programmes for pre-schoolers and those for older children.
- ❏ Watch children as they watch children's TV – what do they enjoy watching?
- ❏ Shoot some sample videos for a children's audience.

Click, read, discover

www.bbc.co.uk/iplayer/tv/categories/childrens
www.itv.com/itvplayer/categories/children/latest
http://milkshake.channel5.com
www.funkidslive.com
www.thechildrensmediaconference.com
http://kidscreen.com – children's entertainment industry news

six
Corporate Presenting

Corporate presenting includes information videos and web presenting for businesses, organisations and charities. Productions are not broadcast on mainstream TV but might be shown in-house as part of the company communications strategy, distributed as DVDs or streamed online. Web presenting is an increasing source of work in which a presenter fronts a company website to give it a more personal feel. Production companies in the corporate sector help the client from script to screen, selecting the right presenter to appear on websites and be the face of the company's corporate vision. Corporate productions can look good on your showreel as production companies often use top of the range high-definition recording techniques and 3D graphics to integrate video into websites.

Case study: Nicole Harvey, Web Presenter

Nicole Harvey is an actor, presenter, voiceover artist and model. She finds corporate presenting jobs advertised on Starnow and Casting Call Pro and via her agent. Her corporate presenting career started with Web Video Store when they needed a presenter with legal experience – Nicole has an LLB. Nicole's presenting work for Web Video Store includes a variety of topics from hearing aids to construction and damp-proof services. Sometimes Nicole is selected on the basis of her reel or previous experience, but on other occasions the client has asked for a screen test.

What are the key presenting skills needed to work in the corporate sector?

❏ Total confidence with Autocue – managing layout of text so it flows evenly – and the ability to learn chunks of script.

❏ Talent to give a knowledgeable-sounding, sincere delivery of scripts that are often very complicated with industry-specific jargon, technical, medical terms, etc. Take the time to research pronunciations.

❏ Versatility – some scripts are playing an expert of some kind, some require you to be the reassuring voice of quality service, giving the promise of customer care.

What advice would you give to new presenters trying to break in to this field?

❏ It is a great area to build one's confidence, and is a strong bread and butter work-stream to tap into.

❏ Have the right suits/smart wardrobe for that world.

❏ Play it straight – corporate clients hate the very sales-y, lots of hand gestures, zesty overenthusiastic cheesy style of presenting.

❏ Adopt a style that is formal but friendly, clear, articulate, even authoritative.

❏ Be confident enough to liaise with the client if needed to understand exactly what delivery they seek. Often on corporate jobs they are less media-experienced than on commercial shoots, or perhaps the crew is skeletal with no director to guide you.

Case study: Debora de Rooy, TV Presenter for Financial Times Ltd

Your presenting job might be under your nose. Are you working for a company that needs in-house videos? Does your company have a website that could do with an in-vision presenter? Does your business have an existing communications magazine that could be adapted to an online video version?

Debora de Rooy, is both Head Benelux and Nordix Asset Management and TV presenter at *Financial Times* Ltd. She devised, produces and

presents *Have We Met?*, online interviews with high profile *Financial Times* staff to promote internal communications.

How did you create *Have We Met?*

After I completed my presenting course I was keen to put my skills into practice within an environment I was comfortable in. Since the *Financial Times* is such a big brand globally, I had this idea of doing a TV show interviewing its employees and finding out more about the people behind the pink paper. I wrote a documentary treatment and presented this to our board. Luckily they liked the idea and I was asked to both produce and present the show. I have been fortunate enough to build experience interviewing influential individuals such as the *Financial Times* Editor and Global Commercial Director. We have an internal channel called Neo where all shows are being hosted.

Debora had some previous presenting experience interviewing bands but her career took off when she decided to focus on the corporate market, using her existing expertise.

How do you combine both roles at the *Financial Times*?

I present to global powerful people nine to five and build skills that I take into the studio and vice versa. Presenting comes first for me so whenever a presenting job comes up I take time off my office job. Luckily both job roles are with the same employer, which makes it a lot easier. However, whenever I do external presenting jobs I think honesty is the best policy. When I asked my employer for flexibility they were luckily very supportive. I do make sure to keep performing well in my office job.

Debora's FT presenting has led to other corporate presenting jobs, including a rebranding campaign in Europe for CBS.

What advice would you give to others wanting to follow your example?

- ❏ Think of areas or topics where you have already acquired an area of expertise.
- ❏ Build a CV.
- ❏ Be proactive and create work for yourself. Do you see any presenting possibilities within your work environment, circle of friends, your local community, your gym or sports/hobby club?

❏ Don't be shy, approach the decision-makers and believe in your ideas and skills.
❏ Get in front of a camera as much as possible to build your confidence.
❏ When you do apply for a corporate presenting job, tailor your background to match their call (within reality, of course).

Case study: Colette Quartermain, Magazine Editor and Business Presenter

Some people become presenters by chance. Colette Quartermain is editor of three Asian editions of *Accounting and Business* magazine for a readership in Hong Kong, mainland China, Singapore and Malaysia. Originally a Chartered Accountant, Colette is now a journalist specialising in accounting, business and finance issues. The print magazine is sent to subscribers who are professional accountants in Asia; the website version of the magazine is available to anyone interested in these areas.

Colette was approached by her employers to present in-vision pieces to camera for the online monthly magazine in order to develop the magazine's profile and communicate to the readers and viewers. Colette didn't initiate the idea of presenting, but since 2012 it has been a regular part of her routine, recording roughly one briefing per month.

How did you start presenting?

I started web broadcasting rather reluctantly as I was nervous about talking to camera without any training. I was persuaded to give it a go so that, as an editor, I could engage more with my readership. I've had training, which has really helped my confidence. I write my own scripts, which I don't find too onerous, as I am a journalist. But it does help to remember that short sentences and uncomplicated language are best on camera, and reading from Autocue is straightforward as long as you slow down the pace and breathe! With print, you often have the luxury of space to get your message across. With presenting it's all about snappy, succinct sentences and you have less scope to explain an issue. Journalists can write beautifully structured sentences that just don't work on TV.

Moving from print to online is an increasing trend in business and B2B (business to business) publishing as video, online interviews, presentations and webinars supplement corporate literature on websites.

What advice would you give to presenters wishing to break into corporate broadcasting?
Find out if there are any opportunities where you work. This has a couple of advantages: you will know your subject and audience already; and you'll be able to manage the expectations of your employers. It also means you'll get experience on the job, which will be useful when you decide to move on.

So it is quite possible that you could already be working for a company that is moving towards online presentation. Like Colette you could find yourself in the right place at the right time to present videos to accompany the printed word. Or, like Debora, you could create a video version of the company's communication strategy.

Case study: Michelle Witton, Actor, Presenter and Lawyer

Michelle Witton studied law at the University of Sydney and practised as a lawyer before coming to the UK to study postgraduate law at Cambridge and acting at Guildford School of Acting and RADA. Michelle works as an actor, lawyer and corporate presenter and recently produced a legal training series.

How did this come about?
I perceived a gap in the market for video-based training on new legislation, The Bribery Act 2010, and I took the idea to a video training company. A team of five, including myself, produced the *Bribery Act Now* series.

There is an upward trend in many professions and industries to train large numbers of people in a cost-effective way. Michelle continues:

In recent years the online training industry has grown. The products of many online training providers, however, focus on graphic-based online training (text plus pictures). I conceived *Bribery Act Now* as an online lecture-series, broken into modules. Online training is replicable, an online lecture-series relieves the burden from legal and training departments to conduct many face-to-face seminars.

What advice do you recommend for presenters wishing to produce video content for corporate broadcasting?

❏ Write what you know. If you're speaking about a topic with natural confidence and authority borne of familiarity it's going to read well to your audience.

❏ Find an affordable and quiet space to do the recording.

❏ Reading a large volume of detailed Autocue material takes a lot of energy. Be prepared, familiar with the scripts, preserve your energy and try to shoot as much as you can early in the day.

❏ It is well worth having a 'dry run' on a day before the shoot, to decide the ideal pace and font size of the Autocue and distance the presenters will be from the camera.

Case study: Paul Tizzard, Live Events and Radio Presenter

Paul Tizzard is a trained presenter, coach and facilitator, and a fear of flying presenter who comperes seminars and delivers a 45-minute psychological talk for up to 250 nervous flyers. He is a keynote speaker at corporate events, participates in corporate seminars and management away days specialising in coaching skills, presentation and management skills. He also presents on hospital radio and local radio.

What advice do you suggest to new presenters trying to break in to the corporate presenting world?

❏ Speak at large conferences and seminars. That way people get to sample you at no cost to them. I have had loads of referrals that way.

❏ Do some courses, get some experience and then do the same sort of courses again. You realise how much you missed the first time round.
❏ Take any kind of presenting work to get time on your feet. There is no shortcut for experience.
❏ No 'off-days' allowed – you always need a professional minimum that is brilliant.
❏ If you are poor at promoting yourself, get help. Join a consultancy that uses associate speakers and they find the work for you.

To do list

❏ View corporate videos to observe tone and content.
❏ Apply for web presenting and corporate presenting jobs.
❏ Take up opportunities to speak in public.
❏ Explore possibilities within your organisation to present online.
❏ Write and record sample corporate presenting videos.

Click, read, discover

www.webvideostore.co.uk
www.mywebpresenters.com
www.thewebpresenterpeople.co.uk
www.tvwebpresenters.co.uk

seven
Financial Presenting

Financial broadcasting is a key part of news and business programme-making. There are dedicated financial channels as well as financial programmes and features on general and news channels. Experts can use their knowledge and real comprehension of the issues, as financial broadcasting in particular uses many highly specialised terms and phrases not used in everyday television.

I advise would-be presenters not to throw out their hard-gained industry skills and understanding when looking for a career change. Even if you have fallen out of love with your current job, with some training, the wisdom you've acquired over years of working in a specialised area can be transferred to a new vocation.

Financial broadcasting offers prospects for reporting, being the guest expert or interviewee, as well as being the main studio anchor. Many banks now have internal video channels, where staff present to camera instead of appearing in internal paper-based communications. If you already work in the financial or business sectors you will probably be familiar with the media output but, as with all genres, you need to watch productions and research current programme-making.

BBC News produces *World Business Report*, a live 15-minute programme transmitted on the BBC News Channel. It features the latest business news from around the world, with live reports from Singapore, Frankfurt and London, and overnight news from New York.

Also produced by BBC News is *HARDtalk*, presented by journalist Stephen Sackur, and transmitted on BBC Two and BBC News Channel. Each episode features an extended interview with a key player on a topical issue. *Asia Business Report* is on the BBC News Channel live from Singapore and features business news and reports.

Bloomberg is a global business and provider of financial information and news, broadcasting across the world. With their HQ in New York, Bloomberg employs more than 15,000 people in 192 locations worldwide, and their output includes TV, radio and magazines. Bloomberg TV is available in more than 310 million homes globally, and programme content incorporates futures, markets, technology, personal finance, interviews and earnings. Its website has a section for careers and internships, just type in the keywords or locations you are interested in to search for opportunities.

CNBC is also US-based, providing real-time financial news, market coverage and business information to 395 million homes across the world. CNBC World is a 24-hour digital TV network offering live financial programming. Sky News reaches more than 107 million homes and is found worldwide in 118 countries.

Other notable broadcasters include Fox Business Network, a US-based TV channel specialising in business and financial news, and Business News Network (BNN), based in Canada broadcasting real time coverage of global market activity.

Where do Financial Presenters come from?

What is their background? Evan Davis is well-known for presenting the business programme, *The Bottom Line*, and *Today* (both BBC Radio 4) and top business reality show BBC's *Dragons' Den*. Previously he was the Economics Editor of the BBC, the most senior Economics Reporter in the corporation and Economics Editor for BBC's *Newsnight*. Before joining the BBC, Evan worked at the Institute for Fiscal Studies and at the London Business School as an Economist.

CNBC's European Reporter, Julia Chatterley spent more than seven years working at Morgan Stanley on the hedge fund desk before moving to financial broadcasting. Her background as a Financial Analyst enables her to cover high-profile business and economic issues for CNBC.

What key skills should a financial TV expert have?

Ros Altmann is an expert on pensions policy, investment banking, savings and retirement. An Economist by training and Investment Banker by profession, Ros is a frequent media commentator on pension issues and interviewee on radio and TV.

You have to be able to distil complex information into words that ordinary people who are not financially savvy can understand. No jargon or, if you use it, explain it. No acronyms, always explain any initials you use as you can't assume viewers will understand what they mean. Those who work in finance use these terms as second nature, but others don't. You need to make finance sound interesting, or pick up things that consumers might be concerned about and help them understand.

Neil Koenig is a BBC Producer and Director who has produced many series about business and economics, working with top UK presenters such as Evan Davis, Peter Day, Stephanie Flanders and Hugh Pym. His credits include *The Bottom Line*, *Stephanomics*, *Start-up Stories*, *The Next Silicon Valleys* and CEO Guru for various BBC TV and radio channels in UK and worldwide.

To be a good business and economics presenter you need just the same skills and attributes that any reporter needs, among them curiosity, imagination, charm, determination, the ability to quickly grasp and convey the key elements of a story (as well as the knack of spotting the right stories in the first place), and microphone / screen presentation skills. Being good with numbers can be useful, but don't forget the needs of your audience. Just because you can understand a balance sheet, doesn't necessarily mean you'll be good at explaining its significance.

So if you're a good journalist, you shouldn't have too much trouble working in this area. Success will depend on ensuring you know the detail and context of the stories you cover inside-out. One exception to this is if you want to work for a specialist business channel. In this case, extensive experience or in-depth knowledge will almost certainly be required.

Case study: Naomi Kerbel, Business News Editor, Sky News

Naomi Kerbel produces *Jeff Randall Live* and presents *Business Round-up*. Naomi also presents science and technology series *The Lab* for Sky and Yahoo. Before joining Sky Naomi worked in banking for six years in the City and retrained as a Broadcast Journalist on the Masters programme at London College of Communication.

Is it essential to have a financial background/journalistic qualification to work in this area of broadcasting?
If you want to go into business journalism you should have a background in business, be it within industry or a qualification. This doesn't matter so much for general reporting/producing. I would say it's pretty essential to have a masters or a postgraduate diploma in journalism, unless you've a proven track record in print and want to switch to TV.

What advice would you give to new Presenters/reporters trying to break in to financial presenting?
If you want to do news-based programming, then get a qualification. If it's not news you want then it's not so essential. However, these days you can get lots of presenting experience by creating your own short videos. Create a YouTube channel. Watch, watch and watch some more. Find a favourite reporter and immerse yourself in their work. Find a favourite news channel and get to know its content inside-out. Get on an internship. Submit ideas. LinkedIn is a great way to make connections.

Ros Altmann offers this advice to new experts trying to break in to this field of work:

> Know your subject – do some research on all areas of consumer finance or company finance, make sure you understand all the basic terms, read some of the experts to see what they say and how they say it. Try to get some contacts in the large financial companies who can help you discuss important issues.

Neil Koenig offers this advice to new presenters:

> One of the main things you'll need is an inexhaustible supply of good ideas. Study the output of the channel you want to work for, identify the gaps in its coverage, and come up with a list of original stories that they would be mad not to feature. The more intriguing your ideas, the more likely you are to be hired.

To do list

❑ Watch financial broadcasting widely.
❑ If you have the expertise and background knowledge for this genre, approach broadcasters.

Click, read, discover

www.bbc.co.uk/news/business
www.bloomberg.com
www.cnbc.com/id/100746255?region=world
http://news.sky.com/business
www.foxbusiness.com/index.html
www.bnn.ca
http://edition.cnn.com/BUSINESS

eight
Food and Drink Presenting

The BBC Food website lists more than 130 different programmes and a staggering number of celebrity chefs. Channel 4, the Good Food Channel and the Food Network also cater for almost every palette in food programming. Recipes, chef interviews, cooking entertainment, reality cooking, food and travel, masterclasses and competitions fill TV schedules as never before: *MasterChef, Saturday Kitchen, The Great British Bake Off, Exploring China, Heston's Fantastical Food, Rachel Allen: Bake!, Paul Hollywood's Bread, Donna Hay: Fresh, Fast, Simple, You Gotta Eat Here, Tom Kerridge's Proper Pub Food, James Martin's Food Map of Britain, Gordon Ramsay's Ultimate Cookery Course, Simon Hopkinson Cooks, Simply Italian, Hairy Bikers' Best of British, Tareq Taylor's Nordic Cookery, Ottolenghi's Mediterranean Feast, Come Dine with Me*, Hugh Fearnley-Whittingstall, Jamie Oliver, Rick Stein, Lorraine Pascale, Madhur Jaffrey, Mary Berry, Nigel Slater, Nigella, Delia – to name a few!

Many celebrity chefs have a background of hard graft in high-profile kitchens and restaurants before launching their TV careers as guest experts or being discovered by production companies. Optomen is a TV production company that specialises in finding new food and drink talent, producing top food shows for UK broadcasters including *Great British Menu* and *What to Eat Now* for BBC Two, *Ramsay's Kitchen Nightmares* and *Heston's Feasts* for Channel 4, and *Market Kitchen* for the Good Food Channel on UKTV. Nicola Moody is Director of Factual Programming at Optomen – how does she find and select presenters for food/drink/cookery programmes?

> We find presenters in lots of different ways. Via word of mouth from people we know in the food and restaurant industry. By spotting talent

in shows we make and working out how to develop them (e.g., *Great British Menu*). By noticing trends and people on Internet sites, in the papers, at restaurants or other food and drink venues we visit personally. By looking at talent suggested by agents in the TV business.

Robi Dutta is Executive Producer of BBC's *Food & Drink*, hosted by Michel Roux Jnr. How does he find talent?

> We use experts, chefs and cooking talent rather than presenters. We use non-food presenters such as Jay Rayner and Giles Coren who are restaurant critics so they have an expertise already. Although presenter Sue Perkins hosts *The Great British Bake Off*, she is there to add a lighter touch to the show, which features experts Mary Berry and Paul Hollywood.
>
> To find new talent we have meetings with agents, some of whom specialise in food. We have in the past done tours to actively look for new food talent, researching specialist magazines and restaurants. The competition is high, and BBC Two in particular seeks real expertise and maturity.

Whether food is your passion or profession, are you confident enough to create a dish under pressure, on live television, and entertain the viewer while being interviewed, and make it look easy?

Restaurant Owner and Head Chef Tony Tobin from The Dining Room, Surrey, started his TV career on ITV's *This Morning* with Richard and Judy when he was 23. That led to him being chef/presenter on *Hot Chefs*, more than 300 appearances on *Ready Steady Cook*, *Can't Cook, Won't Cook*, and more recently as guest chef on *Saturday Kitchen* – all BBC. As most TV recordings are during the day, Tony finds he can juggle his two careers to be back in the kitchen for the evening service. What skills and qualities does Tony recommend for TV success? 'Confidence in what you are cooking and trying to teach, paired with the ability to cook and talk continuously at the same time whilst being bubbly and informative.'

Optomen has discovered several experts who have not presented before. Nicola Moody says:

> We started off the career of Jamie Oliver and created his first TV show – *The Naked Chef*. We also brought the *Two Fat Ladies*, Jennifer Paterson and Clarissa Dickson Wright, to British television and the world. And on *Market Kitchen* for UKTV we gave a number of new presenters their first

break. Matt Tebbutt made his TV debut on the show and honed his presenting skills with us. We are always looking for presenters and experts. New original faces are hugely important to keeping television contemporary, vibrant and surprising and we love finding great new people.

Rebecca Kane and Tomm Coles, two nutrition experts, are making their mark as presenters who can talk with passion and knowledge about food. What are the backgrounds of these new presenters and how are they developing their presenting careers?

Case study: Rebecca Kane, Raw Food Presenter, Author, Founder of www.shineonraw.com

Rebecca Kane is a raw food chef, author, live food demonstrator, and presenter of food demos at London's Olympia and Europe's largest vegan festivals. Her business is raw food. Rebecca has created a number of Videojug demonstrations that help to build up her expert profile.

How did it begin?
It started with a passion for making and sharing quick, easy and tasty food. I went to one event and then was asked to attend another and then another . . . At this point I knew that this was something that I loved doing and I wanted to be able to inspire people to make simple changes to their diet that would positively impact them, their lives and that of their families too.

How do you use video?
Having created many food videos has definitely increased my audience and my credibility. Not only am I asked to attend many shows, even open some, and do lots of interviews, I am now even sent kitchen equipment and books to test and review. Of course seeing yourself on video allows you to hone your skills too and just keep on improving in your chosen field.

What skills do you feel are key to presenting in this field? How do you keep a live audience engaged and entertained?
❏ A passion for food.
❏ It has to taste delicious and be really quick and simple to make.

❑ The ability to think quickly when equipment fails or you forget an ingredient.
❑ Have lots of fun stories and useful tips to share.
❑ Being able to talk and prepare food at the same time is a must.

What advice do you suggest for people wishing to break into food presenting?
Find food events that are related to your style of food interest, contact the organisers and ask if you can do a food demonstration at their event. Keep up-to-date with national food days, such as International Chocolate Day, and use these as a chance to get on the radio and in the press and share your passion. Just keep talking and sharing your love of food.

How do you build up your brand?
I'm continually raising my profile, it's part of my day-to-day business. Whether it's connecting and contributing through social media, like-minded businesses, writing articles for magazines and online blogs, doing interviews or live appearances. I always make sure that everything is brand consistent and supports both my audience and my business.

Less air-time is devoted to vegetarian, vegan, alternative and organic nutrition, but it is only a matter of time before these areas become more fully exploited. Niche programming exists online, featuring local sustainable products for foodies, producers and consumers, such as http://localfoodchannel.tv.

Case study: Tomm Coles, Actor turned Nutritionist, Co-Founder of http://pagetandcoles.com

Tomm Coles, a former actor, spent four years studying at the Institute for Optimum Nutrition and now co-owns a nutrition company with a private clinic on Harley Street. He conducts workshops and seminars in schools and within the corporate sector, publishes an online healthy lifestyle magazine and produces bite-size educational videos explaining key concepts of nutrition.

Although you were an established actor, you are now at the start of your TV presenting career, why did you make the move?

I have been a jobbing actor for more than ten years and initially I set out to study nutrition as a means to support this career. However, as I progressed through my studies, my love of food and nutrition caught up with my love of theatre and when I came to set up my nutrition company it was a no-brainer that I should use the skills I had developed on the stage and explore a career as a health presenter. I have already learnt the importance of doing something that you love doing. If you find this, then naturally you will exude an excitement and a passion when talking to camera. There are a lot of programmes being made about food at the moment and I think it's important to find your niche, what makes you unique, and not be afraid to run with that.

How are you developing your videos?

Online video sharing has given me the freedom to find my own style and voice. As I find my feet and experiment with different presenting styles then websites like Vimeo really allow me the creativity and freedom to do this and learn from the feedback I get. For example, early on I was putting out ten-minute videos but I learned very quickly that people were switching off after a couple of minutes, and I was then able to see a better response when I experimented with shorter videos.

Our video channel enables me to connect with viewers the world over. It's opened up a couple of opportunities to write for magazines in the US, for example, which wouldn't have happened otherwise. From a business perspective it has raised awareness of my company in the UK and the videos provide a great way for me to reinforce our company brand.

How important do you feel it is to have qualifications in this area?

If you are just doing recipes and practical food demonstrations then many a home-taught cook can put out great content and establish incredibly large followings. This area is more about passion and enjoyment of the food in my opinion, and if you have that then you are off to a good start. If you enter into the educational arena, however, there should be a responsibility to fully research the material you are talking about, and to have a level of education to back that up.

Breaking in

How do you break in to this highly popular genre and what skills do you need? As with other genres, uploading YouTube or Vimeo videos to promote your business or expertise should help to raise your profile, whether your area is vegan cookery or wine tasting. What advice does Nicola Moody give to new presenters trying to break in to this genre?

> Dare to be original, dare to be yourself. Don't try to be a me-too of your TV heroes. The copycat will only ever be a copycat. Presenters need to connect with the audience so you need to know how to communicate what you love about food and/or drink and you need to learn how to demonstrate your knowledge but don't preach. TV isn't a university lecture hall.

Tony Tobin suggests: 'Film yourself cooking and presenting your favourite recipe, keep it simple, informative and smiley. Send it to everyone and keep knocking on those doors.'

As with any other genre the showreel is key. Nicola Moody likes to see 'something original, something personal, some wonderful food. We don't want a thesis. You need to grab our attention and know your stuff.'

Robi Dutta says: 'Don't just edit your favourite and best bits on a reel. I'd rather see clips that show how you do something, interacting with other people. Show your personality, warmth, something quirky about you, what makes you different. It is rare to find warmth and likeability.'

Increasingly, as cookery programmes combine with reality TV, there are more opportunities to get discovered by winning a competition. It can take nerves of steel to combine cooking on TV while being judged, but when Gita Mistry entered a BBC TV cookery competition series, *Eating with the Enemy*, hosted by James Martin, she was crowned Britain's Best Home Cook. This accolade has helped to launch her cookery career. Gita is a now a highly sought-after cook, giving demonstrations and appearing at food festivals. From *MasterChef* to *The Great British Bake Off*, an award, or even a nomination, would help to set you apart from the crowd as you market yourself.

What does the future hold for this genre of programming?

Robi Dutta says that the 'chop and chat' style of programmes such as those with Nigella Lawson, Mary Berry and Lorraine Pascale have reached a very high level of beauty and indulgence and the challenge is how to take this forward. In Robi's view, 'future programmes need to explore new ground, perhaps food and emotion or food and personal history'.

Nicola Moody adds: 'Food programming always needs to evolve and move with the audience's appetites. Online is very important for finding new talent as well as then breaking new talent and ideas. On TV we must create new formats that will surprise viewers. Our job is to make high quality popular television – television you don't want to miss. So we are always brainstorming new ways of breaking new ground.'

To do list

- ☐ Research food and drink programmes.
- ☐ Know your subject matter.
- ☐ Practise talking to an audience while cooking.
- ☐ Do live demonstrations of food/drink.
- ☐ Shoot food/drink videos.

Click, read, discover

www.bbc.co.uk/food
www.foodnetwork.co.uk
http://uktv.co.uk/goodfood/homepage/sid/566
www.localfoodchannel.tv
www.optomen.com
www.shineonraw.com
http://pagetandcoles.com
www.videojug.com

nine
International Presenting

I know several UK presenters who use their presenting skills in Europe or the US. Global broadcasters such as Al Jazeera and CNN employ presenters and journalists from all over the world, and if you have a journalism background in particular you could explore opportunities in their many offices abroad. Working in Europe is relatively easy, but applying to work in some countries such as the US can be a lengthy, complex and expensive business, requiring visas, work permits and sponsorship by employers.

Unless you are already a US citizen or lawful resident of the US, you will need a visa and permit to work there. Several different categories of visa exist, such as non-immigrant, immigrant and temporary worker, and it is important that you take the correct route. The O Visa category of non-immigrant temporary worker includes people who display extraordinary achievement in the TV or film industry and lasts up to three years but the visa application will need supporting paperwork and evidence. The employer must apply by petitioning USCIS (US Citizenship and Immigration Services) or going via a US agent and your application must be approved before you can apply for the visa. You should contact your local embassy or consulate for further information, and you may need an interview – there are fees attached. The permit to work, Employment Authorisation Document (EAD), is also required by foreign nationals.

Case study: Marie-Françoise Wolff, TV Presenter and Actor applying to work in the US

Marie-Françoise Wolff's UK TV presenting credits include the Travel Channel and QVC.

What visa are you applying for and can you explain the process involved?
I am applying for an 01 Acting Visa. If you want to be put forward for any TV network shows or work with the big studios, you must have this visa – they won't approve others and in some cases only the green card gets accepted. It is also known to be hard to get. For 'hosting' or 'modelling' you can get a different visa but you can only work in that field you have applied for. If you want to act it's worth applying for the 01 so you are not restricted.

You need a company or agent/manager to sponsor you and an attorney (I used Bernard Sidman, another popular one is Next Stop LAX). For the application they require 'deal memos', which are jobs that you would be coming out to do. In my case I have two films in which I would play the lead with a reputable established producer and my manager is sponsoring me and will endeavour to find me work. They have to submit forms stating the details of the work.

You need six or more references from people who are well established in your profession/respected companies to support your application using wording like 'she is an exceptional actress/presenter . . . we worked together on . . . she was vital to the success of this project'.

You need to submit pay slips from jobs that reflect you are a high earner in your field in the UK. Your attorney will guide you through the process and tell you what they need. It costs around £4,000–5,000. It depends who you go with – it can vary. Mine has just got approved! It took around ten months, this will also vary depending on amendments you might need to make.

After this you need to compile a file of evidence of all your work, reels, jobs, portfolios, CV, magazine articles and press. Everything you can that is impressive and reached a wide audience. Include your training – studying at a reputable drama school was beneficial to my application.

Case study: Sarah Coutts, TV Presenter who moved from UK to US with work

Sometimes it is possible to transfer to the US within your existing company. Sarah Coutts, a Scottish presenter who has worked on several UK-based shopping channels including Rocks and Co, Gems TV and the Jewellery Channel is now presenting for the Liquidation Channel in Texas.

How did you make the move from the UK to the US?
I was working for the Jewellery Channel in the UK, the sister company to the Liquidation Channel. My best friend lives here in Austin so I'd visited the city a few times and loved it. I asked whether I could visit the Liquidation Channel and my company arranged for me to go over for a week. I did three shifts on air while I was there and the next day they offered me a job! I moved there two months later.

What about the administrative side of things?
I was really lucky because I was transferring within a company so my visa was fairly straightforward. However my case is not the norm. My employer paid for my visa and their lawyers worked on all the paperwork. I have a Social Security number over here, which is like a National Insurance number. I currently only pay tax in the United States as this is my full-time job – I don't go back to the UK for work. It may be hard to get here, but once you get here, it's a blast!"

What advice would you give to UK presenters who might be thinking of working in the US?
First get experience in the UK. Just because the Americans love your accent, doesn't mean you instantly get a job. Do your research of companies in the US, research visas, and talk to an Immigration Lawyer who is an expert in entertainment visas. If you can get a sponsor, then half the battle is done. I live in sunshine 11 months of the year, have a swimming pool and pay about 50p per litre of petrol!

Case study: Louise Houghton, UK Presenter working in Europe and London

How about working in Europe? UK presenter Louise Houghton started her career working on the European Drag Racing Championships for Sky Sports, and is now a Broadcast Journalist and presenter on *Euromaxx* for Deutsche Welle TV in Berlin and Co-Producer and presenter for *Balcony TV: Music Sessions* for London Live.

Euromaxx is DWTV's daily lifestyle magazine show. They were searching for native British presenters and contacted Louise after seeing her showreel on YouTube, flew her over to Berlin for a screen test and she got the job. The screen test process was quite rigorous, including researching, writing and presenting links for VT reports, and recording studio links as if the show was live. EU citizens do not need a visa or residence permit to enter or work in Germany.

Have there been any issues with the language barrier?
The majority of people at the casting had some knowledge of the language but I only had the very basics that I learnt at school. There were definitely some drawbacks to not speaking German once I got the job. The directors and crew speak English but now I have learnt more of the language we speak in German. Some things can get lost in translation with regard to studio actions so I have had moments when I have had to adjust my text on the spot because I hadn't previously understood everything.

What's it like living and working in Berlin?
Although people speak English it can be hard when people are having to speak their second language to you and this affects friendships. It used to feel as if life was on hold while I was abroad with work, it has taken two years to find friends here and have a life here too. *Euromaxx* is a live show so, like many TV programmes filmed at prime time, it can prevent you from having the same time off work as others and this can also be a challenge when trying to enjoy life in another city.

Are there any obstacles to working in Europe for UK presenters?
If you are in Germany more than 180 days in the year then legally you need to pay your tax in that country. It is a complicated system and accountants

are very expensive, €100 a month. You need to be sure that nothing is ignored as there are lots of hidden taxes that you wouldn't even have thought of before – like the church tax that you will have to pay unless you fill in a form.

How can UK presenters get started in Europe?
There are a few channels that have offices around Europe, like Eurosport and Red Bull. It is always beneficial to know the language before you work there but as I have experienced, it can be learnt after you get the job if your face fits! The rates of pay are relatively good in Europe for freelance jobs and there is a lot of opportunity at the moment as many companies are using English as their first language. For press conferences they always want a native British speaker with a Standard English accent and this applies for award ceremonies and live events that I have also worked on.

You can of course do international jobs without leaving your UK home. Nicole Harvey, presenter, voiceover artist and actor has a US agent who engages her to work on US voiceovers. Nicole explains:

> I heard of this US voiceover agent through a friend. They can submit me for non-union US jobs and so far it has been very fruitful. They are on the West Coast so the time difference for business dealings is surprising at first: I have been in the cinema buying popcorn and received a phone call to dash home to record an audition ASAP! I did it at midnight – and happily bagged the job.

To do list

❑ Research international TV companies and broadcasters.
❑ View TV widely – digital and online.

Click, read, discover

www.usa.gov
www.uscis.gov

www.london.diplo.de
http://edition.cnn.com
www.aljazeera.com

ten
Local TV and Student TV Presenting

Local TV

In July 2011 the Department of Culture, Media and Sport (DCMS) published a new framework for local TV in the UK. Jeremy Hunt, then Secretary of State, said his key priority was to establish sustainable local TV across the country on digital terrestrial television. Visible on Freeview channel 8 in England and Northern Ireland, or on channel 26 on Freeview in Wales and Scotland, the local TV stations would have prominence on the electronic programme guide and enable local journalism to develop. The BBC committed millions of pounds towards engineering and transmitter costs and purchasing of local news items, and the government committed to superfast broadband to support local TV as it rolls out on the Internet.

Ofcom identified around 60 locations for local TV, invited bids and announced winners for these locations in stages. Grimsby's Estuary TV was the first to start transmitting in November 2013 to Northern Lincolnshire and East Yorkshire and all successful bidders should be on the air by 2016. What does this mean for presenters and journalists?

Steve Perkins was formerly Head of Content Policy at Ofcom, and was involved – among other things – in setting the policy framework for local TV. In 2011, he and Nigel Dacre established Local Digital News, a company that offers consultancy services to local TV and is a founder partner in Notts TV. Steve Perkins explains how Local TV opens up many opportunities.

It's a brilliant way in to mainstream free-to-air TV. For most channels, budgets will need to be distinctly 'realistic', so there will be opportunities in starter-level jobs to get straight on screen in key roles. Budgets will not allow most stations to recruit only experienced staff, so there will be terrific opportunities for those who can show ability to learn on the job, especially if they have relevant educational qualifications.

Martin Head, Creative and Managing Director at Local Local Local Limited, has launched a number of online local television channels, including Stratford upon Avon TV. 'Local TV is a shift in the television landscape of the UK, and opens the door to a whole new generation and type of presenter and reporter. The stations will undoubtedly run on low budgets and have a range of programme styles but they will also offer a great way in to the industry for people who are talented, multi-skilled and flexible.'

London Live, the sister station of the *Evening Standard* newspaper, is the biggest of the local TV licences, the first 24-hour TV channel dedicated to London. According to Louise Houghton, Co-Producer and Co-presenter of *Balcony TV: Music Sessions* for London Live, the target audience is 16–35 years old, and many of the shows have been picked or designed with this in mind – interactive and requiring audience participation to help to create a community within London's diverse population.

> I think the difference with working on a local channel has a lot to do with being accessible to the audience. We want the audience to feel involved and we are always asking them to get in touch via social media to comment or suggest other artists for us to feature. It's all about the local community and because we do live music gigs around the city we hope to meet lots of people along the way, making the city feel a smaller, friendly place – one of the aims hoping to be achieved with the creation of London Live.

Martin Head says:

> All of the new local television stations have to deliver local news as well as a range of other programmes reflecting their area, so there will be all sorts of opportunities for a great many people. Some of these will be traditional presenting roles but there will be a new 'breed' of presenter and reporter often called VJs (video journalists), MOJOs (mobile Journalists), SOMOJOs (social mobile journalists), or even SOLOMOJO, standing for the social local mobile journalist – they all mean a multi-skilled VJ, who knows how to format, structure and deliver a story as

well as how to shoot it and edit it. The future will see a merging of roles, where having a wide palette of skills will have an ever-increasing value.

As more stations come on air across the UK the need for reporters and presenters will increase, especially those with local knowledge. Presenters with a love for their locality might be able to find work in their region, without having to go far from home.

Tina Edwards, music journalist, TV and radio presenter is co-presenter and co-producer of *Balcony TV: Music Sessions* for London Live. 'It's great that the channel are taking risks in this way, as it's highly unlikely other major broadcasters would screen a show that isn't fronted by talent with a certain level of recognition.'

What does Steve Perkins feel is key to breaking in to Local TV? 'Local knowledge is important, particularly for reporters, and local stations will require that in the mix. But talented outsiders will be able to break through as well. Be flexible, be realistic, and (if you can) consider volunteering as a way in.'

Martin Head adds:

> Local TV answers the call by many people for more local information and that often the 'local news' or 'regional news' currently offered by broadcasters seems to 'never be about where I live or work'. The current licences being awarded by Ofcom are for 12 years, but increasingly there will also be online channels as well, offering local video news and TV content. The television landscape will be bound to change over the next 12 years as the Internet develops and the high speed broadband rollout happens, but the need for local content will, I believe, continue to grow even when the method of delivery changes.

It's early days for the local TV rollout in the UK and only time will tell how it develops, but the process has been kick-started and may well develop into online and cross media platforms with innovative content.

Student TV

Student TV stations exist all over the UK, mostly in universities, having started in 1964 with Glasgow University Student TV station, GUST. Content is generally distributed via a website or the Internet, and many stations are run by students themselves. Bournemouth University has Jump TV, the University of Manchester has Fuse TV, Hull University has HUUTV, NUTS is the TV station

at the University of Nottingham, Sonar is the TV station at the University of Southampton Solent, and Spark TV is at the University of Sunderland to name a few.

The National Student Television Association (NaSTA) was founded more than 40 years ago to support and promote student television. Now around 40 student TV stations are members and take part in their annual awards and conferences. If you have the opportunity to get involved in student TV it is a fantastic way to build up experience and it can be career changing.

NaSTA Awards include categories for Best On-screen Male and Female, one previous winner being Ore Oduba who presented for LSUTV when studying at Loughborough University and won Best On-screen Male in 2007. Ore went on to become the youngest ever anchor for CBBC's *Newsround* and *Sportsround*, and presents for BBC Sport and BBC Breakfast as sports presenter.

BBC *Blue Peter* presenter Lindsey Russell learned her presenting skills at Bristol University's student TV station UBTV and was entered for NaSTA's Best On-screen Female in 2012/2013. Lindsey went on to win *Blue Peter – You Decide*, chosen as the 36th *Blue Peter* host out of 20,000 applicants.

There are other awards that recognise student TV talent, such as the Royal Television Society Student Awards, *Guardian* Student Media Awards, and NUS Student Awards, so this is an area worth getting involved with.

To do list

- ❑ View local TV channels.
- ❑ Contact local TV providers and seek work experience or apply for vacancies.
- ❑ Become a local expert.
- ❑ Get involved with your student TV station.

Click, read, discover

http://licensing.ofcom.org.uk/tv-broadcast-licences/current-licensees/local-tv/
www.londonlive.co.uk
http://nasta.tv
www.rts.org.uk
www.theguardian.com/media/studentmediaawards
www.nusawards.org.uk

eleven
News Presenting

One of the most commonly asked questions is: 'Do I need journalism quali-
fications to become a newsreader?' Alex Gerlis, former Assistant Editor for the
BBC *One O'clock News*, *Six O'clock News* and Head of Training at the BBC
College of Journalism, confirms:

> No question about it: newsreaders need to be able to write stories, frame
> questions, conduct interviews, handle live television and deal with break-
> ing news. Only trained journalists are capable of this as only they have
> the skills to handle story finding and storytelling, along with all the ethical
> and legal dimensions of journalism. It is a serious mistake to assume that
> TV news presenting is about looking good and an ability to read the
> Autocue.

News presenters do not just read the news – reading the bulletin is the final
part of the process. Their talent is to make it look easy, with authority and
warmth. They have to understand the background to the stories from a jour-
nalistic point of view, know who's who in UK politics and world affairs and,
above all, cope with the stress of the job.

Today's journalists require a wide range of abilities – it's a multi-platform
world where packages are produced for TV, radio and online. Reporters
research and write the scripts, interview and present the items, film and record,
edit, send the edited story to the newsroom and upload to social media. They
make editorial decisions throughout this process, as well as use technical and
performance skills.

What skills do you need to be a Newsreader?

Maxine Mawhinney is a BBC national News Anchor, currently reading the news on BBC One and the BBC News Channel. In a career spanning more than 35 years she has reported from across the world. Her credits include ITN, Ireland Correspondent at Sky News, Asian News Editor for Reuters TV and Washington Correspondent for GMTV. Maxine explains that the news anchor role has changed just as the news landscape has changed with 24-hour news, Internet and social media. 'It's not that long ago that the people bringing you the TV news bulletins were newsreaders. Now it is unlikely that you will succeed unless you are a journalist.'

Maxine clarifies what is being asked of today's TV journalists and TV news anchors, and the pressures they face:

> The journalist in the field will become a mini-anchor of a segment in the news programme when the studio hands over to them; they might introduce their own package, do an interview and then invite the audience for a look around the location – a show and tell. The journalist in the field is dealing only with that story.
>
> The journalist in the studio in the anchor chair is dealing with all of the stories on the running order; this is particularly acute on a 24-hour rolling news channel. One minute you can be doing a political interview, the next talking to a business leader, the next doing some breaking news, then possibly some sport.
>
> You need the journalistic background to handle all of the above and to put it into context. There is a lot of ad-libbing – it must be factual, informative and accessible to the audience, not rambling and certainly not drying up. Sometimes you have to sustain with very little information because if you say 'we will bring you more later' the audience immediately switches channels to see what everyone else is broadcasting.
>
> So you need to know what you are talking about, you need to keep up-to-the-minute with the news, you need background reading from broadsheets to tabloids, current affairs magazines to *Hello!* magazine. You never know when you will need that nugget of information. The job in the studio is every bit as challenging as the job on the road.

Julian Worricker has been working at the BBC since 1985 and is currently a presenter for the BBC News Channel's rolling news and the BBC World Service's *Weekend* programme. Julian also presents various programmes and

documentaries for BBC Radio 4, including *Any Answers?* and the obituary programme *Last Word*. Julian says:

> The ability to stay calm under pressure is key to success in front of a camera. So much good presentation has that at its core, because that calmness will mean the presenter retains clarity of thought, focus and an ability to communicate in an unhurried way. A presenter who feels confident within him/herself, even when things are going wrong, will continue to convey that confidence to the viewer.

Julian does regular work within the BBC for their College of Journalism, training other presenters. Successful presentation is not just the ability to remain in control, it's also down to the preparation beforehand. He adds:

> Editorially that confidence comes from being sure about the kernel of each news story. If a presenter can – in a few words – sum up what each story is about, and build any interview that comes his/her way around those few words, then that's another route to greater confidence and a sense of orderly calm. And *in extremis*, if things are going so wrong that chaos can't be disguised, then be prepared to laugh at yourself. Viewers enjoy a bit of self-deprecation.

Maxine Mawhinney, also an on-air trainer at the BBC College of Journalism, agrees that preparation is vital. 'My main advice is to get as much experience as you can – it will show on air and stand you in good stead. Never try to wing it – always do your prep work especially for interviews. Listen – and listen very carefully – to what a guest answers to your questions. It is from there that the news will come.

Training and breaking in

Mark Wray, currently Acting Head at the BBC College of Journalism, is responsible for the training of the BBC's 8,000 journalists. A journalist himself for 33 years in print and broadcast, Mark was a strand editor at BBC Radio 5 Live before joining the College of Journalism in 2006. Mark explains:

> Most news presenters will have gone through a production route first, then into an on-air reporting role and then into presentation. For those working at network level, some overseas reporting experience is com-

mon. Some might start in radio and then move into television. Some move in the opposite direction. Some move from regional TV to network or BBC World. Others come from other broadcasters. It's very rare for a presenter to be recruited with no previous broadcast experience.

Julian Worricker works across radio and TV. He says:

> There's no obvious route to follow if you want to be a TV news presenter. However I think it's vital that aspiring presenters have done some reporting and / or production before they're let loose in front of a camera. In other words, they've done the journalistic hard graft, before the lights come on and the makeup is applied. That's not just so that people adhere to some kind of imaginary pecking order, it's simply because presenters who've 'been there and done it' tend to be better presenters. They won't ask daft questions of correspondents in the field because they've been that correspondent in the field themselves; they won't let a politician off the hook with an array of ill-thought-out questions because they've had to provide questions for presenters themselves in the past. Experience in all aspects of the job is very important before a presenter can hold it together in the studio. Oh, and comb your hair!

Mark Wray explains that there was a time when acting could be a route into presentation but such are the demands on a news presenter in a live environment now that a really strong foundation in journalism is really a prerequisite. 'It's possible to make the transition from text journalism (online or print), particularly if you've been an on-air contributor / pundit, but this is unusual. As more people set up their own blogs, vlogs or YouTube channels it's possible to get noticed in that space but possibly more by smaller, independent broadcasters in the first instance.'

The BBC Academy offers training and advice in journalism, production and technology, and incorporates the BBC College of Journalism. One highly competitive scheme that attracts 3,000 applicants for around 12 places is the BBC Journalism Trainee Scheme, a year-long paid traineeship combining training from the BBC College of Journalism with placements in BBC radio, TV and online. This scheme is not for complete beginners.

The Broadcast Journalism Training Council (BJTC) accredits UK journalism courses within higher education, and the National Council for the Training of Journalists (NCTJ) delivers accredited UK journalism training courses.

What training would a Newsreader receive?

According to Mark Wray:

> This depends on their experience. Established BBC presenters should receive regular, detailed feedback from their Editors and, if requested, from College of Journalism coaches. Those newer to presentation would receive a coaching programme that is likely to include support from an experienced coach, who may be a current presenter themselves. Anyone coming to the BBC from outside would also receive induction training, some of it mandatory, including the Journalism Foundation course, which covers BBC editorial values, among other things.

Journalism experience gained on newspapers, on the radio or online is a very useful background to have for TV journalism. Routes into the industry can be via local papers, local TV, local radio, online news/features/magazines, production jobs in news, journalism training courses or work experience in any of the above.

Susie Fowler-Watt presents *Look East*, the BBC's regional news programme for the eastern counties. Susie studied Broadcast Journalism at the London College of Printing, worked as a production assistant at BBC Radio Surrey and as a reporter for BBC Radio Suffolk. After a stint as a radio news producer, Susie then moved to Westminster to become assistant producer for BBC political programmes before becoming the political correspondent and then presenter for *Look East*. She says:

> Be prepared to start at the bottom, and work your way up. The more journalism experience you have, the better. And then, if you think this is something you would like to try – ask to shadow a presenter and maybe have a go at doing their bulletin afterwards. Record it and watch it back with a viewer's eye – you'll be amazed how many irritating habits you'll notice!

What are the differences, if any, between national and regional presenting? Susie explains:

> Regional news – like breakfast news – tends to be more 'friendly', and often has lighter stories and ad-libbing in the latter half. This means the presenters need to show more of their personality than they do on national news bulletins. We also conduct more interviews with guests

(as opposed to correspondents), so you often have to become a mini-expert on subjects with very short notice! It is important for a regional presenter to be inclusive with the audience – talking about 'our' region, for example. We live here too, and the viewers feel like they know us.

Case study: Jayson Mansaray, Arts and Culture Reporter, Arise News

Jayson Mansaray is an Australian-born British broadcast journalist who has worked in radio, television and online as a presenter and broadcast journalist. Starting in regional radio, he has worked at BBC London, Sky News, Channel 5 and now Arise News.

How did you get started on this career path?

I did a postgraduate diploma in Broadcast Journalism at London College of Communication and started doing work experience at BBC London 94.9. While on work experience I pitched stories the whole time and eventually got onto Joanne Good and Dotun Adebayo's programmes. From there I moved through regional radio to national television at Channel 5, Sky News and Arise News.

How important is it to have journalism training to do your job? Could you do your job now if you had not trained as a broadcast journalist?

I definitely could not have, media law surrounding things like defamation is something very valuable I learnt. But also the general graft, the difference between creative or print writing versus writing for broadcast.

What qualities and skills do you need to be an on-air reporter?

A good memory is great, although it is the one thing I struggle with most! Definitely able to stay calm under pressure and make a story interesting, people forget that reportage is storytelling too.

What advice would you give to someone who wants to become a presenter/broadcast journalist?

It's not an easy path, and I think my journey still has further to go, but I wouldn't trade the low pay or bad jobs at the start of my career, it made me who I am today. Be hungry for success and always work hard no matter

how far down (or up) the ladder you are. Be patient, it very rarely happens overnight and that is quite often a good thing.

Is it more competitive than it used to be?
My experience is that it is incredibly competitive but the attitudes towards what makes a good presenter are changing. Being an authority is important but people are looking for personality more than ever, they want to engage with audiences. There are also more mediums for broadcast.

Opportunities

Alex Gerlis says: 'There are more outlets with the development of continuous news stations, Internet TV and regional and local television. Although there are clearly more opportunities, at the same time there are far more people going into journalism, not least through the university Broadcast Journalism courses.'

Below are some of the key news organisations to be familiar with and to approach for training and work opportunities – there are many career options for journalists, not just multi-platform, but globally.

❑ BBC's New Broadcasting House in London brings together BBC's national and international radio, television and online journalism under one roof for the first time – its newsroom is the largest in Europe.

❑ ITN produces news programmes for the UK's biggest commercial broadcasters – ITV, Channel 4 and Channel 5 – and offers careers and work experience in news and production.

❑ Sky News, the UK's first dedicated 24-hour news channel reaches 107 million homes across 118 countries.

❑ Al Jazeera English broadcasts 24 hours a day to 220 million households in more than 100 countries, and has bureaux all over the world, with its HQ in Doha, Qatar. Al Jazeera programming includes Africa, Americas, Asia-Pacific, Central and South Asia, Europe and Middle East.

❑ CNN, a Time Warner company, has more than 36 bureaux worldwide and employs more than 4,000 journalists globally, with programming for Asia/South Asia, Europe/Middle East/Africa, and North America/Latin America.

So with journalism qualifications you could explore a huge variety of destinations in broadcasting.

The final word goes to Alex Gerlis:

> I would be concerned about someone who starts out with the (perhaps sole) aim of becoming a presenter. They should think in terms of becoming a broadcast journalist (which means not just television, but other journalism platforms too) and then move into presenting as their career develops. The most important thing to remember is this: you can be a Journalist without being a presenter, but you cannot be a TV news presenter without also being a journalist.

To do list

❑ Research a wide range of news programmes on TV, online and on the radio.

❑ Explore journalism training courses.

❑ Seek work experience on newspapers, Internet news channels, TV or radio.

Click, read, discover

www.bjtc.org.uk/index.php
www.nctj.com
www.bbc.co.uk/news
www.bbc.co.uk/careers/home
www.bbc.co.uk/careers/trainee-schemes
www.itn.co.uk/Home/TopStories
www.aljazeera.com
http://edition.cnn.com
http://news.sky.com
www.itv.com/news/uk
www.channel4.com/news
www.channel5.com/shows/5-news

US

www.spj.org/newsroomtraining.asp – Society of Professional Journalists, USC
www.journalism.columbia.edu/page/8-training-programs/8 – Columbia
 University, training for non-degree students

twelve
Science Presenting

How important is it to have a credible science background to work in science broadcasting? Do you need a PhD in Astrophysics, Geomorphology or Mechanical Engineering, or is enthusiasm enough?

Where do Science Presenters come from?

BBC's popular *Bang Goes the Theory*, a twenty-first-century successor to *Tomorrow's World*, makes science more accessible for a family audience. One of the presenters is Maggie Philbin, award-winning science broadcaster and CEO of TeenTech. Maggie did not start out as a science presenter, so how did she break into science and technology broadcasting?

> I was working on a BBC Saturday morning show called *Swap Shop* and was spotted by a Science Producer who offered me a job on *Tomorrow's World*. It was an amazing opportunity and I've reported on science and tech ever since. At school I'd enjoyed Physics and Maths and it felt like coming home.

Maggie's co-presenters on *Bang Goes the Theory* include scientists Liz Bonnin, who qualified in Biochemistry, and Jem Stansfield, who has a degree in Aeronautics. Jem used his engineering qualifications to create special effects for movies such as *Lost in Space* and to build amazing exhibits for the Science Museum and the Royal Observatory. He explains how he got into TV:

One day RTF television asked if I would be an expert on their *Scrapheap Challenge* series for Channel 4. Around the same time an ITV and a BBC production also asked if I could design and build experiments and inventions for them. Being freelance I was able to take on the jobs as they all seemed interesting. The need for new ideas and the nature of TV science turned out to be a pretty good fit for the skills I'd built up.

As with other genres, the current trend in science is to use experts. Jim Franks, Executive Producer at the Newton Channel, explains:

> The age of the non-specialist factual presenter is over, especially for STEM (Science, Technology, Engineering, Mathematics) subjects. People will only listen to you if they believe you know your subject and thus being a subject expert is the first priority. Virtually all of the current generation of science presenters were scientists/subject experts first, presenters second, such as Brian Cox, Jim Al-Khalili, Liz Bonnin, Jem Stansfield, Michael Mosley, Chris Packham, Kevin Fong, Robert Winston – even Dara Ó Briain.

Richard Wyllie, Producer of Channel 4's *Dispatches*, *How Weight Watchers Make Their Millions*, and *Unlocking the Secrets of Our Cells: The Nobel Prize*, says:

> One of the jobs of a presenter is to ask pertinent, intelligent questions, and in science it's very hard to do this without any knowledge of the subject. A contributor who is being interviewed will often give a better performance if they think the person they are talking to understands what they are saying and is as enthusiastic about it as they are.

Former science teacher turned presenter Matthew Tosh, has a Physics degree and a PGCE. He is also a qualified pyrotechnician. His presenting credits include *Junk Food Science* for Teachers TV and *History of Maths* for Glasshead TV. Matthew agrees on the importance of having a science/technology background:

> Broadcasters are becoming more discerning in their choice of specialists on screen and will look to see what your credentials are. That's not to say it isn't possible without qualifications, but you'll need to work that bit harder and prove that you are knowledgeable and experienced in a particular subject area.

'In practice, as no one can be an expert at everything, many expert science presenters end up presenting scripts outside of their specialist areas," Jem Stansfield points out. 'Where I see a science background as important is that as a presenter if you're being asked to say anything, you have a responsibility to use your knowledge to check that it's factually correct.'

Personality versus expertise

What is more important in this area of programming, expertise or the ability to present in an engaging manner? Personality plays a huge part in ratings success, and we expect television programmes to educate and entertain. How do producers see the balance between personality and expertise?

David Gilbert's credits include Executive Producer of *Richard Hammond's Engineering Connections* for National Geographic and the BBC, Series Producer of *Future Weapons* for the Discovery Channel and *The Gadget Show* on Channel 5. He says:

> Presenters must be experts – ideally with a doctorate or be published – and have a winning personality. Discovery and National Geographic like to use people who would undertake the adventures whether the cameras are present or not. Expertise and personality in equal measure. To present, you can't have one without the other.

Richard Wyllie offers up a different point of view:

> Personality is more important because that is what is going to come across on screen. It's no good knowing everything about particle physics if you tell that information with all the enthusiasm of a dishcloth. The experts are there to have the expertise, the presenter is there to guide the viewer through the story and the subject."

Presenter Matthew Tosh agrees, but adds: 'That's a tricky one. Personality definitely has the edge, but it doesn't mean that expertise isn't important. Never pretend to be an expert on a subject if you don't know much about it; you will come unstuck sooner or later.'

Breaking in

Assuming you have knowledge and personality, how can you break in to this exciting field? Do you need a reel, a screen test or can you win a contract with a successful interview? David Gilbert gives this advice to presenters wishing to break into science broadcasting:

- ❏ Be highly qualified in the area you want to present in.
- ❏ Watch carefully how the best science presenters work onscreen.
- ❏ Find a topic you're passionate about and shoot a four-minute 'taster' tape.
- ❏ Identify the companies that make the sort of programmes you'd like to make.
- ❏ Independent production companies are the best to approach – if they see potential they'll help you.

This echoes the advice given for all genres – be motivated, create material and market yourself. It is possible to gain work if you are an expert who has not presented before.

Richard Wyllie reveals:

> If I'm looking for a presenter primarily I'll look for someone with experience in the role. Unfortunately it's the kind of industry where, if you've already done it, directors know you've got it in you. Ideally this will be on a broadcast television programme, but even if it's a simple reel done in their kitchen then I'll definitely consider it. I'll ask to meet them, to check that they've got knowledge of the subject and see what they have to add. I'm usually keen for a presenter to have some input in the programme's content – it'll mean they have more of a passion for it and this will come out onscreen. If it's a first time presenter, I'll then do a screen test to see what the presenter is like to work with and how they come across on camera.

Both David Gilbert and Richard Wyllie confirm that if you do not possess a reel or presenting experience you could still be employable. However, there is little time to practise on set during the production period, and new presenters have to get it right from the start, so if you lack experience, acquire some training in order to be able to hit the ground running.

When David Gilbert was Series Producer on *Future Weapons* for the Discovery Channel, he used an expert new to TV:

TV is constantly in search of good talent. Richard Machowicz is an ex-Navy SEAL who wanted to do TV. He was a complete newbie to TV, so I went on the road to induct him into the ways of TV! As the show was all about weapons, he knew his subject well; all that had to be done was a bit of media training.

Matthew Tosh adds this advice on breaking in:

❑ Get yourself known in the science communication industry. If you've never heard of science communication, then you aren't going to get very far.
❑ Go to science events, festivals, get to know your local museums and science centres – they often run their own workshops, presentations and shows.
❑ Create your own material (e.g., writing a blog, maintaining a YouTube channel, giving talks).
❑ Have relevant content on your showreel – there's no point pitching to science producers if your reel only shows you at rock festivals or talking to people about fashion.
❑ Note which production companies are making science programmes and write to them for work experience.
❑ If you are lucky enough to get a placement anywhere, then make yourself indispensable.

Case study – Fran Scott, Science and Engineering Presenter

Fran Scott qualified in Neuroscience. Her TV credits include science consultant on *Absolute Genius with Dick and Dom*, *How to be Epic @ Everything*, Reporter on *Newsround* – all for CBBC – and *Stargazing Live*.

How did you break in to science presenting?
I was a show writer and presenter at the Science Museum, and a researcher for children's science books. I applied for every BBC work experience placement, I emailed the producer of every children's science programme whose name I could find in the credits until I got offered a job as a runner at September Films. On day three of this job, while delivering the tea to the series producer I saw he was looking up 'how to make giant bubbles'. I mentioned that you just need glycerine, and offered to go and buy some.

He asked me how on earth I knew that and I told him. From then on I was banned from making tea.

The programme was *Richard Hammond's Blast Lab* (CBBC) and it was a fantastic springboard for me. As the only scientist on the team I designed all the in-studio science games, oversaw the explanatory graphics, briefed the presenters and also designed some of the larger science stunts. I even ghostwrote and advised on the accompanying book and science kits.

How do you find presenting work?
I watch TV religiously, but don't just watch it . . . I analyse it. I make sure I know exactly what each company is making, and the direction they are heading in. If that direction is something I think I fit with, I contact them.

What advice would you give to presenters wishing to break into science broadcasting?
Apply to the BBC Science Department, but also apply to every independent production company that makes programmes you like. Science at the BBC is difficult to get into; during my time there I was often the only non-Oxbridge graduate, and the only one not to have done some sort of Science Communication course, but don't let that stop you.

Independent production companies have a much more open door, but staff turnaround is high. Sending them just one email isn't going to get you anywhere. Send one every month, or better still pay them a visit. Someone will, eventually, give you an opportunity.

If you do want to go into science presenting, I would say that the best route is to stay in science. The media increasingly wants actual practicing scientists to communicate it. Even if the show they're presenting is not in their field of expertise, the fact that they do have an area of expertise is an instant tick.

Susan Etok was selected for the BBC Expert Women media training scheme. Susan is a Materials Engineer, Intellectual Property Specialist and TV presenter with a PhD in Materials Engineering, a Master's in Management of Intellectual Property and a PG Dip in Intellectual Property Law. She is also a Science Associate at the Natural History Museum. When asked how important it is to have a science/technology background to present in this genre, she says:

Unlike other genres such as lifestyle and entertainment where basic research on the subject matter would suffice, it is not easy to become an 'instant expert' in science and technology. A technical background makes programme fact-checking, script research and interviewing run more smoothly. TV presenting is a very competitive field and having an expertise gives the presenter an edge over other candidates.

Postgraduate training

The Science Communication Unit at Imperial College London launched the first Science Communication Master's degree in the UK in 1991. They offer MSc Science Communication and MSc Science Media Production, training science graduates and scientists for work in the media. The Open University course MSc in Science and Society offers an opportunity to pursue contemporary issues in science communication, science education and public engagement with science. The Science Communication Unit at the University of West of England trains would-be science communicators via dedicated courses and workshops, offering an MSc or Postgraduate Diploma in Science Communication. Sheffield University offers a one-year full-time or a two-year part-time MSc Science Communication course to help you develop your skills to communicate science effectively to a general audience.

Get involved in the science communication scene, keep up with current issues and debates, new ideas and take part in practical workshops and discussions. Research the Annual Science Communication Conference run by the Science in Society team at the British Science Association.

Weather presenting

If you have a strong interest in weather, and the right qualifications, weather presenting is another option to consider, either as a career in its own right or as a stepping stone to other areas of presenting. Carol Kirkwood – BBC Weather presenter since 1998 and named Best TV Weather presenter at the Television and Radio Industries Club (TRIC) Awards in 2003, 2008, 2009, 2012, 2013 and 2014 – trained at the Met Office. ITV Weather presenter and Meteorologist Sian Lloyd also trained at the Met Office. She has won TRIC's Best Weather presenter award twice and been nominated four times. As well as TV appearances Sian posts weather updates on her website and Twitter. Although based in meteorology, Sian also presents documentaries, other TV and radio shows

and has guested on *Celebrity MasterChef*, *Celebrity Total Wipeout*, and Carol is a regular contributor to BBC's *The One Show*.

All BBC weather presenters are trained meteorologists. The UK Met Office College, based in Exeter, runs weather presenter training courses for television and radio. You will need to have degree-level qualifications (or equivalent) in physical sciences such as Physics, Mathematics, Geography or Environmental Studies. The Met Office training is rigorous and involves an initial six-month forecasting course followed by two years working in the subject. It costs several thousand pounds and individuals are often sponsored by employers. Weather presenters on channels other than the BBC may be qualified meteorologists, but not necessarily.

What does the future hold for science broadcasting? The experts sum up

This is a growing area – TV has a real hunger for it. But TV goes in fashion cycles, and Discovery, National Geographic, Channel 4 and the BBC are producing programming that is more factual entertainment than pure specialist factual. What do I mean by that? Formats are becoming a lot like *Top Gear*. Lots of jeopardy, mission-led, character-led series. The presenter today must be prepared to be an action man or woman to present. Think Bear Grylls.

David Gilbert

I think there are some great opportunities and some very important stories that need telling. The industry needs powerful, committed reporters and programme-makers who can share insight in an engaging and accurate way. The world of media is changing but the great thing is there are so many more ways that you can share good content with the rest of the world.

Maggie Philbin

I do think one of the things we'll see is more experts presenting onscreen. Although a lot of people find science interesting, there is a significant amount of scepticism about what some scientists do and the amount of money that is spent on research. There is also widespread concern for the number of young people pursuing science and engineering careers. One way of addressing this would be to fund more science-related output and include more science specialists on the screen.

Matthew Tosh

Science and technology broadcasting seems to be on the up – Brian Cox (presenter of BBC's *Wonders of Life*) has certainly helped with that, but we are approaching a golden age of physics, with new discoveries that will have huge impacts on our lives. As we rely more on global communications, feel the effects of climate change and medicine becomes more personalised, consumers will be looking for more information, and people who can explain these clearly and simply will be extremely welcome to programme-makers.

<div align="right">Richard Wyllie</div>

To do list

- ❑ Research your specialist area and keep up-to-date with the latest developments.
- ❑ Write a blog, make videos and upload them to your own website or YouTube, Vimeo, etc., to build a profile as an expert.
- ❑ Seek presenting and reporting opportunities in print, radio or online broadcasting, practise being the expert, presenter or guest.
- ❑ List TV programmes and online channels to approach for presenting opportunities.
- ❑ Enrol on specialist TV presenter sites for self-promotion.

Click, read, discover

Bang Goes the Theory, BBC
Material World, BBC Radio 4
Richard Hammond's Engineering Connections, BBC
Richard Hammond's Blast Lab, CBBC
Absolute Genius with Dick and Dom, CBBC
How to be Epic @ Everything, CBBC
www.discoveryuk.com
http://natgeotv.com/uk
www.theguardian.com/science/series/the-newton-channel-science-videos

Media promotion

www.beatvexpert.com
http://thewomensroom.org.uk
www.hersay.co.uk

Science communication

www.imperial.ac.uk
www.open.ac.uk
http://uwe.ac.uk
www.sheffield.ac.uk
www.britishscienceassociation.org

Weather presenting

www.metoffice.gov.uk/training/industry/broadcast
www.rmets.org
www.rmets.org/our-activities/careers-accreditation-academic-and-vocational-
 qualifications/spotlight-careers – different careers in meteorology, including
 TV weather presenting
www.tvweathergirl.com – Sian Lloyd's weather website

thirteen
Shopping Channel Presenting

There are currently more than 30 different shopping channels on Sky, plus online channels, providing a huge amount of employment for presenters. QVC broadcasts 17 hours of live presenter-led content per day, Ideal World, Create and Craft are on the air day and night . . . you can now buy almost anything via TV shopping channels.

Where do shopping channel presenters come from? Presenters often have experience in other areas of TV, demonstrating in stores or exhibitions, as an auction assistant or on shopping channels in the past, theatre or radio. Shopping channels often turn to agents for presenting talent and recommendations.

Various styles of shopping channel

Different types of shopping channels require different styles of selling, from intimate soft sell to speed auctions. QVC style is a conversation between the main host and the guest expert – an interview where the guest explains the product in a natural, friendly way to the main presenter. The unique selling point for QVC is the demo; the guest expert or presenter will always try out the product and show the viewer how it works. The QVC studio has domestic settings with clean lines and an unfussy look. The tone is homely, calmer than many other shopping channels and reassuring, and is intended to make the viewer feel their life would be more complete if they purchased the item.

Ideal World TV and Create and Craft are close in style to QVC, connecting with the products and the craft itself, using the interview / demo format rather than the hard sell.

There are several channels dedicated purely to jewellery. Rocks & Co. sells gems, bracelets, chains, collections, earrings, necklaces, pendants and rings. Again, one presenter leads the sales, making it personal to the viewer by mentioning the first names of the callers. They hold timed falling auctions and offer products until the quantity has sold, so the presenter has to react very quickly to changes in price and quantity, while also demonstrating and describing the product. Gems TV sells diamonds, rings, earrings, wristwear and neckwear. The presenter is generally on their own, really relating to the viewer and encouraging them to take part in the auctions and deals.

Cate Conway, guest expert presenter on QVC, explains:

> On Gems TV it's quite an intimate set up. The presenter generally sits at a table facing the viewer and showing them small items. They need to maintain a very high standard of hand-care and be able to create numerous 'scenarios' for the items such as where the viewer could wear that item or who it would be a good gift for, etc. This is of course true for the other channels but there are fewer varieties of products on jewellery channels so in my opinion this seems harder.

Other niche channels include Jewellery Maker, which sells gems, beads, jewellery kits, threading materials, chains, tools and DVDs.

The Presenter

Paul Slater has worked at QVC for 18 years, and is Presenter Performance Manager, having previously worked as a Senior Director. What qualities does he look for in QVC presenters? 'We look for people who have good experience in TV and generally with some kind of sales background. They need to be commercially aware and understand what is required here. We prefer to cherry-pick people.'

Alison Keenan has presented on QVC since 2000, with many years of production experience including presenting on Granada's daytime show *This Morning*. She says:

> To work in this job you need to have the ability to retain information, cope with talkback (producer and director giving you direction and

timings through your earpiece), and work within the strictures of live presentation. You need boundless energy and enthusiasm, the ability to share space with other presenters/guests without talking over them or hogging the limelight, and accept that, although not all products you sell are things you would necessarily have in your own home or life, there will always be someone out there who wishes to buy. Always find a positive slant and never draw negative parallels with other products – chances are you will be selling them one day!

The guest expert

Many presenting roles in shopping channels are not actually the main host, but guests, experts, assistants or demonstrators. These are not the key presenting positions but it can be easier to find work in these areas if you are starting out. Don't worry if you are not an expert as it is possible to acquire product knowledge and become an expert. QVC uses hundreds of guest experts per year, including those from a performance background with a passion for particular products.

Presenter Marie-Françoise Wolff has TV presenting credits on the Travel Channel and QVC, where she represents Kipling bags. 'Working with Kipling and QVC has been amazing. I have travelled to QVC US, and designed my own bags in Belgium (Kipling HQ). We did an outside broadcast in Antwerp for Kipling and I have been filming behind the scenes at their fashion previews in stunning cities like Barcelona.'

Cate Conway moved from a career in marketing to presenting, becoming a QVC guest expert presenter in kitchen appliances. She has represented several brands including Morphy Richards, SodaStream and Prestige. She went on a TV presenter training course and entered QVC's Search for a presenter competition in 2007, making it through three rounds before being eliminated. This experience gave her the confidence to approach them again after she had gained some more training, and she was taken on as a guest expert. She says: 'For shopping channels you need excellent communication skills, the ability to think under pressure and demonstrate the product at the same, to explain how the product fits into the viewer's life, and to create interesting and comprehensive demonstrations.'

Ideal World guest presenter, personal trainer and nutritionist Anita Albrecht was spotted by a gym member who thought she would be ideal to promote their equipment, AbTrak, and The Wave fitness products on the channel. She offers this advice:

You have to keep an interesting flow of conversation going, show enthusiasm for your product and really relate to the product. I keep myself in great shape as I will only enhance sales if I look good on camera. You have to be believable, natural and bubbly and you absolutely have to know your product. The more knowledge you have about how the product works, who uses it, how they use it and ways to demonstrate it, then you will never run out of things to talk about.

A day in the life of Alison Keenan, QVC presenter

Working as a shopping channel presenter is hard! It's challenging and interesting, tiring yet exhilarating, live and, unlike other TV shows, there is no Autocue – everything that comes out of your mouth has to be original and informative! You have to give of yourself, engage with an unseen customer, and sell them things they can't physically get their hands on! It is essentially retail on TV – we are here to sell, and it can be tough with targets to meet, and the constant competition from other TV channels whose audiences we share.

QVC is an incredibly well-equipped business, and we are all able to prep ahead of our days on air by accessing the system from home. Prior to my shift I will have printed out the list of products I have to sell – and will have been in touch with the buyer, or arranged to meet them on the day to talk through the salient points of the products. Documents that give background information, price and detail are provided by the coordinating producers, and I find the Internet is incredibly useful for additional information about brands and special guests, so I work a great deal from home too.

Most products are represented and the guests from the company arrive two hours before their shows, so I will have time talking to them prior to the sell. All the products are laid out on trolleys backstage, and I spend some time looking over my scheduled hours, making notes on the product info, and catching up with the Producer and Director for those hours to talk through any specific offers/positioning of brands/layout of set and the all-important targets! I then change my clothes, apply my own makeup and style my hair, get my mic and talkback, and head off to the studio. A day shift can mean up to four hours on air selling up to 40 products and it is imperative you know every item you will be selling, have spoken to all the relative guests and have all the information you need. Once you're on air, the breaks are very short and rare.

A day in the life of Cate Conway, QVC guest expert

It is incredibly hard work. All my friends thought I pranced in to hair and makeup, then waltzed into the studio, talked about food and then got a limo home. That was very far from the case. Because I worked with kitchen gadgets I had to bring a lot of food to the studio on the train. Sometimes I had to get there four hours early to do the preparations, and I had to call in the day before too. I spent hours planning, shopping, chopping, cooking and setting up. (Oh, and I had to do my own hair and makeup.)

The hardest thing was that sometimes we couldn't get into the studio to do the setup until minutes before as that area might have been being used for something else. It's quite surreal and exciting though and was something I loved doing. I think it might be quite different for people who aren't selling kitchen goods, there would be much less to set up! You need to be incredibly calm. Lots of things go wrong or change at the last minute so you have to be able to roll with the punches. You also need to be super organised, have a fantastic memory for facts and be able to work them into a natural conversation.

As with other genres of TV there is a well-worn path in shopping channels from being a successful guest or expert to becoming the main presenter. If you impress the producers as someone who can be a good interviewee, you can be spotted and be given your own show.

Screen tests and breaking in

Background preparation and research is vital, both on the product and on the channel itself. You need to understand the brand and the way presenters talk on air.

Cate Conway was asked to prepare a ten-minute sell on a product of her choice, to include a demo and being interviewed by the main presenter. She chose a slow cooker as it was a product she was familiar with and she felt she could sell it confidently, bought the ingredients for an Irish stew and brought one she'd made earlier so she and the presenter could taste the dish as part of the item. Structuring your 'sell' is key to a successful performance.

Anita Albrecht had to do a screen test for Ideal World before being employed as a fitness expert. 'It involved working with one of the other main Ideal World presenters and rehearsing a live show about one of the products, AbTrak, to

see how the interaction between us was, how quickly I could speak on my feet and of course, how engaging I was with the viewers both from both a personality and a visual perspective.'

As an expert live director who has worked at several shopping channels including QVC, the Jewellery Channel and Gems TV, Del Brown has directed hundreds of presenter and guest expert screen tests. He explains:

> The presenter is taken to an off-line studio where they are introduced to the camera operator, the in-house presenter, director and the person looking to recruit. Sometimes the person being auditioned is asked to bring in a product to demonstrate, or they may not be given a product until they arrive at their audition.
>
> It's important to note that there is usually no rehearsal. Everything is recorded so that the team and the product buyer can review the audition. It's always a good idea to watch the channel you're going to audition for before showing up for your screen test, get familiar with the channel style and format.
>
> If you've been asked to bring in your own product to demonstrate, make sure you know it inside-out. Bring along any other props that you feel would help you demonstrate it better, for example, if you're demonstrating an iron, bring along some creased clothes. Don't stop there, bring along a selection of clothes made of different fabrics. Really think about what you're demonstrating and show you've thought about it. There's nothing worse than a potential guest presenter turning up for an audition having done no preparation and just delivering what is called a dry sell.

Because shopping channels work without rehearsals, as well as testing your performance skills the producers will be checking your technical abilities – there are key TV techniques that shopping channel presenters are expected to know. Del Brown explains:

❑ I want to enjoy watching the presenter. I want to feel included, engaged and interested in what they have to say. I need to feel they are sincere and trustworthy.

❑ I'm also looking for professionalism. I want to feel comfortable working with them. I will test out their talkback skills, so I can judge how comfortable they are working with open talkback. If a presenter can't handle open talkback, they immediately lose points.

❑ I like working with presenters that wait for me to say 'cue' before they start speaking and also those who are good at talking to time. There is

nothing more frightening from a live director's perspective than to be working with a presenter who stops talking early, or who overruns when you're trying to keep a show on time.

❑ When a product is being demonstrated, it's vital that the presenter holds the item still and when pointing things out, turns the product to face the camera and holds it long enough for us to get the shot.

When it comes to presenters, QVC presenter Performance Manager Paul Slater says the channel are looking for, 'sales acumen, personality, an ability to communicate and someone who is aspirational to our audience (which is generally female and over 40)'.

You can approach a shopping channel at any point in the year to be a main host or expert, send them a clip of your demo and ask for a screen test. The channel matches guest experts with brands. Model, presenter and fashion expert Kerrie Newton approached QVC's talent manager with a link to her shopping channel demo online. For her audition Kerrie was told she would be presenting Isaac Mizrahi clothing and to arrive early to familiarise herself with the garments she would be showcasing.

> I had four weeks to prepare for this audition – only my fourth audition to date. I studied Isaac Mizrahi, reading everything online, watched QVC US and UK making sure to watch Isaac Mizrahi guest presenting on the channel, followed him on Twitter and Facebook, started to script my sell and practised.

Prior to your screen test Del Brown advises: 'Consider the shopping channel's target audience. If for example you're pitching to QVC, don't send photographs of yourself or show up for a screen test wearing leather jeans and a crop top. Rather project a more wholesome impression.'

'If you get to audition try and be as much like the current presenters in attitude as you can,' says Cate Conway. 'Film yourself selling and interacting with a product then watch it back. Do this as much as you can before the audition. You cannot over-prepare.'

QVC runs training seminars for guest presenters a few times a year. This is a one-day session for up to 15 guests who have passed their guest audition to learn more about the company, practise their sells and review them. It is the only official training that presenters get prior to going on air although, once on air, guests do get feedback from QVC.

Case study: Sarah Coutts, Presenter Liquidation Channel

Sarah Coutts is a Scottish presenter working full-time for Liquidation Channel, a jewellery shopping network in Austin, Texas. Originally an actress, Sarah has a background in sales and an interest in jewellery and fashion.

How did you break in to shopping channel presenting?
I answered an ad for Rocks & Co., sent them my showreel, CV and a covering letter and they called me in for an interview. A week later I had to do 30 minutes on air, live, as part of my audition. They brought me in for several trial shifts and before long I was working regularly for them.

What is it like being a shopping channel presenter?
Being a shopping channel presenter is loads of fun! Every day is different, you have to be on the ball and you always have to come up with different things to say and make it as interesting as possible for the viewer. I love that it's live. It's not all fun and games, there's a serious business side to the industry. Because it's a shopping channel you have targets to hit . . . hourly, daily, monthly targets . . . if you're not hitting your targets, or at least getting as close as you possibly can to them then there's an issue. You're responsible for making the company money and if you don't then there's always somebody else willing to try your job, in a flash!

What differences are there between UK and US shopping channels?
The presenting style isn't that different in my experience. The only differences are in the language, they have different terms for things, for example in the UK we have P&P – postage and packaging – in the US it's S&H – shipping and handling.

What advice would you give to presenters wishing to break into UK shopping channel broadcasting?
❑ You have two jobs to do – you have to entertain but you also have to sell a product. A background in sales will put you ahead of the game.
❑ If you're not an expert in something, then learn. I wasn't an expert in gemstones and jewellery before I started on Rocks & Co. and I had to learn very quickly.

- ❑ Watch shopping channels, look at the different presenters. Note what you like and don't like about them.
- ❑ Be yourself. The whole point of someone hiring a presenter is because it's you that they like.
- ❑ Never, ever, ever think that sounding like a shouty car salesman is a good idea.
- ❑ Think about the features of the product – why are people going to buy it, why do you like it, what makes it special, how is it going to make life better?
- ❑ Buy a thesaurus! You'll be surprised at how many words there are to use when describing something.

Does being a shopping channel presenter close doors?

One of the most frequent questions I get asked about shopping channel presenting is whether it closes doors to presenting other genres of TV. The skills required to present on shopping channels are highly technical and in demand, setting you up for a range of presenting jobs in the future, if you wish to move on from shopping channels to other types of programming.

Del Brown sums up:

> Shopping channels are live, unrehearsed and unscripted, working with open talkback and multi-cameras. What an excellent training ground for anyone wanting a career in television presenting! Most shopping channels are like lifestyle daytime television, with a huge graphic on the screen and a tendency towards selling products. Other than that, the format can include cookery and technical demonstrations, interviews with celebrities and live music performances – everything you'd see on ITV's *This Morning*, BBC's *The Alan Titchmarsh Show* or *The One Show*.

To do list

- ❑ View shopping channels on TV and online, analyse their different styles of presentation.
- ❑ Think about which shopping channel presenting style suits you: the hard sell, the auction or the conversational demo / interview.

❏ Practise talking to time while doing a shopping channel demo.
❏ Shoot demos with products you are passionate about and upload them to YouTube.
❏ Approach shopping channels direct with links to your work and ask for a screen test.

Click, read, discover

http://qvcuk.com
www.createandcraft.tv
www.idealworld.tv
www.rocksandco.com
www.thejewellerychannel.tv
www.jmldirect.com

US

www.qvc.com
www.hsn.com
www.createtv.com
www.liquidationchannel.com

fourteen
Sports Presenting

Football to Formula 1, weightlifting to wrestling, boxing to beach volleyball – sports coverage is big business. BT Sport, launched in August 2013, is a major player, spending hundreds of millions of pounds on Premier League matches and Premiership Rugby, as well as acquiring sports channels such as ESPN. Rival Sky Sports has six HD channels viewable on TV, mobile phones and tablets; BBC Sport broadcasts on TV, radio and online; plus Channel 4, Channel 5 and hundreds of Internet sports channels create a huge array of choice for the sports enthusiast.

Sports programming consumes presenters – BBC's broadcasts of the London 2012 Olympics were the most comprehensive ever, with live transmissions of every sport from every venue throughout the day. Their presenting and commentary teams covered archery, diving, equestrian, gymnastics, hockey, rowing, sailing, table tennis, water polo, wrestling and much more. Channel 4 scheduled more than 500 hours of sport during the 12-day 2012 Paralympic Games and 50% of the presenting team were disabled, including former Paralympic wheelchair basketball medallist Ade Adepitan, middle-distance runner Danny Crates, and swimmer Rachael Latham.

Former professional tennis player Sue Barker, former footballer Gary Lineker and former cricketer Phil Tufnell started out as competitors before becoming sports personalities and quiz show hosts. What does it take to become a successful sports presenter?

Being a sports presenter

Graham Miller was Senior Sports Correspondent for ITN on ITV. He says:

> It has to be the best job in the world. I was paid to travel the planet,
> covering all the major sporting events. It gives you a real insight into the
> world of sport at the highest level. And as a keen observer of human
> behaviour I learned an awful lot about the importance of confidence,
> attitude and performance under pressure.

Matt Lorenzo's sport presenting credits include the World Cup, Champions
League, Formula 1, UEFA and Soccerex. Matt created *Off the Bar*, the first ad-
funded show on Sky Sports, hosted the Olympics for the London Organising
Committee of the Olympic Games and is now the face of *The Times* and *Sunday
Times* online Premier League service. He says: 'If you can't play a sport well –
and I can't – it has to be the next best thing. You don't feel like you're working
half the time because you're working at a subject you enjoy. You meet your
heroes and you end up counting some of them as friends.'

Annie Emmerson is a former world number one Duathlete turned sports
writer and presenter. Her sporting highlights include being a seven-time
European Triathlon Cup winner and winner of the UK Half-Ironman. Annie
is now a sports commentator and presenter for the BBC, Channel 4, Channel
5 and Sky. She says: 'Being a sports presenter is a lot of fun. The live commen-
tary work can be nerve-wracking at times, but it gets easier with experience
and time. I love the buzz of filming, it reminds me of the excitement I used to
get when I was racing; exhilarating at times and challenging at others.'

What skills do you need?

Experts agree it can be a lot of hard work, but it is worth it. The key skills that
are emphasised again and again are knowledge and research. Do you need to
be a journalist? Graham Miller says:

> Experience of journalism is crucial. A journalistic training teaches you to
> ask the important questions that the audience want answered. It gives
> you the understanding of what things mean. And it allows you to dig out
> the most important aspect as you see it. The current fashion is to have
> ex-sports stars in the job. Now I don't question their inside knowledge
> and personal take on things. But I do question their lack of journalistic

'nous' to ask the right question at the right time. They sometimes miss the main story of the day. It needs a journalist in there to identify the news.

What if your experience of sport is at amateur level? Annie Emmerson says: 'Enthusiastic amateurs can make great presenters because they do tend to be very knowledgeable and passionate about sport so it is by no means essential to have raced at the top level. You don't have to have participated in high-profile sport, but some experience at any level is pretty important.'

Presenter Christina Nicolaides has credits on Sentra FM, a dedicated sports radio station in Athens, as well as on Eurosport and *Best of the Bets* on Sky, previewing the Premier League, European Games, Champions League and Europa League. She recommends:

> Research! The more knowledge you have on your event, the more pre-pared you are to handle anything that comes up. It is very different from presenting in a studio environment. Make eye contact with the crowd and smile, even if they are yards away because you are normally being broadcast on large screens all over the event.

Annie Emmerson agrees:

> Knowledge is so important, you can get away with quite a lot if you know your facts and have lots of information on the athletes and sports you're presenting on. I think a big personality is a good thing as sport is meant to be fun and entertaining, so the presenter needs to be able to deliver in a fun, knowledgeable and positive manner.

Matt Lorenzo's credits also include *Sky Sports News Breakfast Show* and *Goals on Sunday*. His invaluable top tips are:

❑ Be relaxed in front of a camera and lucid on and off it.
❑ Do your homework – you can become an expert on anything if you put the hours in.
❑ Make sure you know what you are talking about – what if the prompter breaks or someone asks you a question about what you have just read.
❑ Sport is generally not hard news, so you can enjoy talking about the game with your interviewee.
❑ When reporting from an event, learn your intro and outro, and try to work out when you need to start the latter.

❏ Treat the camera as your mum and forget that a couple of million others may be tuning in.
❏ If you're comfortable on camera it will look that way at home and half of your battle is won.
❏ If you can ad lib or think of something apposite to say if you're given 30 seconds to fill then you'll do very well.

Breaking in

Sport, like many other genres, offers new opportunities with the growth of niche online programming. Football clubs such as Manchester United and Arsenal have their own TV channels showing live coverage, interviews, under-21s and under-18s matches, highlights, replays and features. Sports presenting has always been one of the most sought-after jobs, and there are more opportunities than ever before, but that has only raised the competition. How did Christina Nicolaides, Matt Lorenzo and Annie Emmerson break in?

Christina Nicolaides always had a strong interest in sport through her father who was a professional footballer. A friend introduced her to Eurosport who were looking for a multi-lingual presenter. Her CV and video clips were sent to the bosses of the IRC Rally and she got the job. How can you shine in a screen test? Christina advises: 'Watch as much sport as possible. You have to live and breathe sport and really know your stuff – especially if you are female. If you are not passionate about sport, choose another niche. Be authentic. Do what you love. It will make you a better presenter.'

Matt Lorenzo's interest also stemmed from his father who was the first football commentator on ITV. Matt worked his way up through local newspapers as a journalist working on rock music columns, becoming sports editor, film reviewer, motoring correspondent and working on Saturdays as match reporter for LBC before joining Radio Solent as a reporter. He joined the BBC as a sports assistant producer on *Match of the Day*, *Grandstand* and *Breakfast Time*, and became the first sports presenter to appear on Sky TV.

As with all genres of presenting, it's important to network and build up your contacts with potential employers. Luckily for Annie Emmerson she got to know the TV production company who filmed most of her UK races for Channel 4 during her career as a professional athlete. When she retired, they asked her to commentate for them and her TV presenting career grew from there. What advice does Annie have for those wanting to break in?

Make as many contacts as possible and, without being too pushy, you need to constantly be emailing people and sending your showreel off.

Every day some time must be spent on keeping up with the news and doing research – like any news, sports news is always changing!

To do list

- ❑ Watch sports programming.
- ❑ Research your subject.
- ❑ Record some sports presenting items at matches and games.
- ❑ Shoot interviews with accessible players.
- ❑ Start a sports blog.
- ❑ Get experience in sports journalism, in print, online or radio.

Click, read, discover

www.skysports.com
http://sport.bt.com
www.bbc.co.uk/sport
www.itv.com/sport
www.channel4.com/sport/index.html
www.channel5.com/shows?genre=sport
www.tv.manutd.com/home
http://player.arsenal.com
www.aljazeera.com/sport
http://edition.cnn.com/sport
@sportsTVJobs

fifteen
Technology Presenting

Are you a bit of geek when it comes to gadgets and technology? Can you explain complex information to a non-technical viewer? Are you up-to-date with the latest news in this field?

What backgrounds do Technology Presenters have?

One of the longest running UK technology series is Channel 5's *The Gadget Show*, with 18 series since 2004, gaining 1.8 million viewers at its peak. The show reviews the latest gadgets and technology, sets records, creates challenges, looks at best buys and caters for both specialist and general audiences. It is so successful it has led to *Gadget Show Live*, huge live presentations of the latest must-have gadgets. There have been various presenters over the years, including Jason Bradbury, Suzi Perry, Ortis Deley, Jon Bentley and Rachel Riley.

Where do Technology Presenters come from?

Jason Bradbury says:

> I studied Theatre, Film and TV at Bristol University. There I met a young David Walliams, with whom I struck up a friendship and formed a comedy double-act. My experience in comedy clubs gave me the confidence that is at the core of any performer. I also gained a lot of verbal dexterity from the cut-throat live nature of comedy club work. The technology bit stems from my lifelong fascination with technology and science.

Prior to *The Gadget Show*, Jason presented *The Web Review* for ITV and the award-winning science series *Gross!* on Discovery Kids. Jason's own inventions include the world's first working jet-powered hoverboard, and he is a six-time world record holder, including the world's fastest jet-powered luge, the world's fastest water-powered car, and the world's fastest jump with an RC car.

David Gilbert, whose credits include Series Producer on *The Gadget Show*, explains: 'Jason Bradbury was already a gadget expert and enthusiast when *The Gadget Show* launched in 2004. This kept the programme in good stead. The others were enthusiasts but are supported by a strong team of producers.'

What about co-presenter Jon Bentley? He read Geography at Oxford, worked for the Ford Motor Company and then joined the BBC as researcher on BBC's *Top Gear*, going on to become producer and editor of the show before launching *Fifth Gear*. 'I was Series Producing *Fifth Gear* for North One TV and Channel 5. *Fifth Gear* was doing well for the channel and they asked North One to come up with a technology format. I was keen to be involved with the show and it was suggested that I should be added to the list of people being screen-tested.'

David McClelland is one of *The Gadget Show*'s live presenters. His TV credits include BBC One's *Rip Off Britain* as technology expert and regular spots as an expert technologist for *Channel 4 News*, CNN and Bloomberg. His online presenting credits include: *Fast Forward*, a future trends and technology show; *The Innovation Show*, about the latest developments in IT and technology; and *Computing Magazine* live online web seminars. Although David did Computer Science at A Level, he went on to follow another of his passions and originally trained as an actor at drama school.

> To bolster my biography's technology credentials I began to write articles for technology magazines, blogs and websites, as well as my own website. I joined my industry's professional body, the Chartered Institute for IT, which has been great for networking and added gravity to my biography. I also became a STEM Ambassador, part of a UK volunteer programme that aims to inspire schoolchildren in Science, Technology, Engineering and Maths subjects – a terrific experience in many ways.

What's it like being a Technology Presenter?

The BBC's flagship technology programme *Click* broadcasts across five BBC channels including BBC World News, BBC Two, BBC UK News Channel, BBC Breakfast and BBC Radio. The show features gadgets, games and computer

industry news presented by Spencer Kelly, with Kate Russell reporting on websites and apps in the Webscape section of the programme – anything from an app to help you run a marathon to an app to make food more memorable. Kate started in children's programmes, has been writing about technology, gaming and the Internet since 1995 and is a regular expert and columnist on TV and in magazines. She recently published *Working the Cloud* for small businesses and entrepreneurs who want to get ahead online. What's it like reporting for *Click*?

> I have a weekly segment in the show reviewing websites and apps. Every Wednesday I do my research and scripting, keeping abreast of the many changes happening online and making sure we have the most important and interesting releases and developments for the upcoming show at the weekend. On Thursday I head into the BBC for 9am, an hour before my editor will arrive, so that I can print out the scripts and film the screenshots we will need for the day's edit. When my editor arrives he ingests all the footage and prepares the timeline while I pick out the music we will need and prepare the paperwork for compliance and music reporting as well as posting the segment on the BBC website. We then edit the segment, which is around four-and-a-half minutes, and deliver it to the main editing suite next-door to be put into the show, which airs for the first time on Saturday morning.

Is it important to have a technology qualification to present in this genre?

Although Spencer Kelly gained a double first in Computer Science at Cambridge, Jason Bradbury, Jon Bentley and David McClelland have varied backgrounds at degree level. It is not necessary to have a formal technology qualification to present in this genre, but according to Jason Bradbury, 'if someone is going to spend £1,000 of hard-earned cash on something you have recommended, you need to reek of integrity otherwise they will smell a rat. It helps if, like me, you are a bona fide geek but you could probably get up to speed by immersing yourself in the world of technology for a year; reading every blog, magazine and tech news report every day.'

David McClelland agrees: 'While a formal qualification isn't necessary to present in the genre, I would like to think that a passion, strong interest or at least curiosity about science and technology would be the minimum that a presenter in this area should have behind them.'

Mario Louis, Researcher on *The Gadget Show* and *Gadget Show Live* explains that presenters receive back-up research from the production team:

> While a little personal knowledge is expected, you don't have to be an expert in everything as there is a team of people that will make sure presenters are fully briefed before we film anything. A presenter on *The Gadget Show* would be expected to know basics about things like 4G and a little about how it works but would not be expected to know the finer details.

Jon Bentley confirms that the production team offers a massive amount of support to a presenter, providing all the content, structuring the programme or item, giving coaching in the field and monitoring performance. But he thinks the best results are where the presenter has lots of input.

> Some presenters can be very good at writing the script and practically authoring and producing items and whole shows. In the fields I've worked in – cars and consumer technology – the importance is enthusiasm and passion rather than an actual science or technology background. You don't have to be an engineer to talk engagingly and expertly about cars. You don't have to have a degree in computing to present engaging items on the latest laptops or tablets.

Kate Russell reveals: 'I am entirely self-taught. In fact I left school at 17 with no real qualifications to speak of. If you decide, like me, to forge your own path and experience, you will have to demonstrate you are far more dedicated and passionate than your peers who have qualifications to prove their commitment.'

Breaking in

David McClelland was juggling a successful career both on the stage and in IT contracts. He took up an opportunity to present some online videos for an IT publication's website and found that standing in front of a camera and talking about technology was a great match for his two passions, so began to think more seriously about a career as a presenter. He followed this up by taking a two-day course in presenting. 'Aside from the practical training in skills like talking to time, using talkback and interview technique, the two most important things the course gave me were advice on picking an expertise and the confidence that I was now ready to begin working as a presenter.'

How can you help yourself to get discovered as a technology presenter? Jason Bradbury advises:

> Start reviewing gadgets on YouTube, start the transformation from gadget enthusiast to gadget ninja. If you don't know what RFID is or the data rate of LTE or what processor the latest must-have smartphone has on board then go and do a gardening programme. Be funny, uber-knowledgeable, find a way of distinguishing yourself – the way you look, the way you review, the words you use – have no illusions of how knowledgeable ordinary punters are on forums and social networks. Do all of this and you might stand a chance. Finally there is star quality – that supposedly random and ethereal something that celebs have: well, the good news is star quality is simply the execution of all of the above.

Kate Russell agrees that setting up a blog, making podcasts or a video-log are all ways to demonstrate your passion and knowledge, and to build an audience.

> Your social media following is like a currency in today's market. There is a lot of competition online so you will have to work hard and be consistent. And in the early days don't annoy potential viewers / readers with intrusive advertising. You will not earn enough initially to make it worthwhile, so just build your audience as an investment into your future.

Don't fall into the trap of trying to copy your role model. Presenting is personality driven so allow your own personality to shine through.

The future?

The future is online. CNET is a high-profile online technology site that reviews the latest products, hosts tutorials, showcases new releases, provides expert opinions and has the very latest tech news. *Wired* is an online magazine with news, reviews, podcasts and videos, and Element 14, an engineering TV site, features videos on Arduino, Raspberry Pi and 3D printing.

What does the future hold for technology broadcasting? According to Jason Bradbury:

> Fully electric cars, mind-controlled mobile phones, super real computer games – the wonders of technology will need to be explained to the wider audience for many years to come. What is changing is the way in which

people will receive those reviews, the explosion of YouTube in one way challenges television and in another opens up technology presenting to anyone with a smartphone camera. The technology review stars of tomorrow will come from YouTube so what are you waiting for? Grab that electric ducted fan engine, strap it on your BMX and start filming yourself.

To do list

- ❑ Research your specialist area and keep up-to-date with the latest developments online, in print and on TV.
- ❑ Write a blog, make videos and upload them to your own website or YouTube, Vimeo, etc., to build a profile as an expert.
- ❑ Seek presenting and reporting opportunities in print, radio or online broadcasting, practise being the expert presenter or guest.
- ❑ List TV programmes, production companies and channels to approach for presenting/work experience opportunities.
- ❑ Enrol on specialist TV presenter sites that advertise professional consultants such as those listed below.

Click, read, discover

http://gadgetshow.channel5.com
www.bbc.co.uk/programmes/p002w6r2 – *Click*
www.davidmcclelland.co.uk
http://katerussell.weebly.com
www.jasonbradbury.com
www.jonbentley.pwp.blueyonder.co.uk
www.cnet.com
www.wired.co.uk
www.element14.com/community/community/element14tv

Media promotion

www.beatvexpert.com
http://thewomensroom.org.uk
www.hersay.co.uk

sixteen
Working in TV Production

Some presenters break in by working in TV production first and making the move from behind the scenes to in front of the camera. If you start as part of the production team you could learn how to create programme ideas, research content, write scripts, plan, shoot, record and edit, and – most importantly – discover what is expected of a TV presenter. How do you get into TV production? What kinds of roles should you aim for and how do you move from runner or producer to presenter?

How to find TV production jobs

There are dozens of websites that list TV production job alerts. A quick online search reveals a wealth of easily accessible information. You can register free on sites such as BBC Jobs, ITV Jobs or *Guardian* Jobs, type in your search criteria and then you will be alerted when vacancies come up that match your search. Sites such as www.theunitlist.com post production job details several times a day. Some sites are subscription-only but you don't need to join too many as the same jobs might be advertised on different sites.

Jude Winstanley is an experienced TV Production Manager with more than 15 years in the broadcast TV industry. In 2004 she set up a round robin job vacancy email list, which eventually became The Unit List. It has more than 23,000 followers on Twitter and Jude runs the service alongside her day job. What advice does Jude offer to people wanting to enter the TV industry?

> Don't apply for every job you fancy. Although it appears to be a casual and unstructured industry, it actually isn't. Realistically, apply for jobs

such as runner or logger, as you won't have the knowledge of storytelling, logistics, budgeting, scheduling, legal or compliance to be considered for anything more senior for a while, even if you had the title of Producer at university. Don't try to move into a senior role too quickly – learn as much as you can and work hard to make contacts without being too pushy. Your contacts are what will help you secure future employment by recommendation.

Production job titles are changing as roles become more multi-skilled, so camera operators may be required to edit, and researchers may need to shoot. There is a huge range of jobs from production secretary to editor, designer to shooting assistant producer to name a few, but for those without experience, runner is the industry-accepted first rung on the ladder – even if you are a graduate with first class honours. Keep tabs on your favourite sites and apply as soon as a potential job comes up as vacancies can be filled in minutes. Have your updated CV ready, and ensure your contact details are up-to-date and that you can be contacted easily. A missed call can be a missed job.

Has job seeking and finding changed in the past few years? Jude Winstanley: 'In the past few years, Facebook seems to be used more widely as a first port of call. It's a select circle of contacts that can be trusted by the user and then they try a few specialist groups with a wider reach before moving to a direct recruitment website service. It's an instant way of reaching job seekers for very little effort and no expense.'

Networking is another key way in. Look for free seminars and talks run by organisations that promote young talent; keep a contacts list of everyone you meet who may be able to offer you a position; watch TV programme end credits and contact production companies direct; use free online listings of production companies and research who to approach. Explore the Royal Television Society (RTS) Futures events, ITV and BBC trainee schemes, the Network at the Edinburgh Festival for training, Production Base for net-working, and use LinkedIn to widen your database of contacts by asking for introductions.

Competition is fierce, especially in early summer when TV, Media and Film Production graduates seek jobs. That said, competition is tough all year round for most jobs in the media industry. If you are only interested in being a presenter and nothing else, this route may not suit you, as being a runner can involve very long hours and dedication above and beyond the call of duty! If you are asked to make 20 cups of tea for the team you need to do it with a smile or you may not be asked back. You will not be popular if your attitude reveals that you are only doing this job as a stepping-stone.

But, if you are genuinely keen to learn about the industry and willing to put in the hours, being a runner is an excellent starting point. You will mix with presenters, see how they work, take part in the process of putting together a show and learn professional expectations. Depending on your duties you might experience pre-production, production and post-production. In time you may be able to put yourself forward to work with the camera team and shoot some test pieces, either as a stand in for the presenter, or some vox pops with yourself as a reporter. You will also be well placed to practise using Autocue and talking to camera. Ask for a screen test – many well-known presenters have started out by working in production first, and no doubt it gives a very good grounding.

From runner to TV presenter

Seema Pathan's presenting credits include roving reporter on CBBC's *Match of the Day Kickabout, Sportsround*, co-host on Channel4's *The Wright Stuff* with Matthew Wright and presenter of her own radio show on Westside Radio. How did Seema get started?

> After graduating from university with a Sociology and Politics degree, I realised that I had no idea what I wanted to do career-wise. I had always been a big sports fan and thought that maybe a career within sport would be a viable option. I had heard that most people within television start as a runner so I decided to send my CV to Sky Sports and applied for a runner's position. I was lucky enough to be called in for an interview and as they say the rest is history!

Following on from her runner role, Seema felt she wanted to pursue presenting, took some training and went for auditions. She quickly found success with a range of digital TV channels, secured an agent and her career took off. Does Seema recommend starting as a runner and did it help her on her way to being a presenter?

> My position as a runner certainly helped me to understand the responsibilities of the presenter and also the team behind the scenes. This includes the team in the gallery, the floor managers, the production researchers and all the people involved in making sure that programme runs smoothly. The presenter is the face that the viewers associate with; however, behind the scenes there is a dedicated team in place to ensure

this happens. Understanding this process is vital in delivering the requirements of a presenter.

I would absolutely recommend starting as a runner as you are given the opportunity to understand how the world of television operates and how each role within the team is crucial to the final output. This insight will help you to define exactly what you want to do as most of the time you can try a few different positions before deciding which best suits you.

Case study – Naomi Kerbel, from Producer to TV Presenter

Naomi Kerbel is Business News Editor and presenter at Sky News, producing financial programming such as *Jeff Randall Live* and presenting *Business Round-Up* and *The LaB* for Sky and Yahoo.

Having spent several years working for Goldman Sachs in the City, Naomi wanted to combine her financial knowledge with her love of performing – Naomi had been a child actor and was professionally trained. Her route to presenting was via producing and a postgraduate Journalism qualification that enabled her to move from the City to the media. She now mixes her passion for presenting with working in production.

What was your path to this successful combination?
I pitched and produced my own weekly business show for the Sky News website and iPad. By doing that I had total control of the product and also could do as many takes as I needed to. I could learn and create my brand slightly off the main onscreen radar.

What screen tests and interview processes did you have to go through to move from producing to presenting?
The pitch process was quite lengthy and circuitous. I did a few screen tests and got mixed feedback but I knew that if I could have a regular slot I would improve week on week. I started off by only voicing the track and painting my voice with pictures over the top to tell the story, as I got better I started letting myself be in it more!

How useful was it to have worked in production before being onscreen?
It was essential to do production beforehand. Not only to build up contacts and a support network but also from a practical point of view, using the systems, knowing the editors, scripting.

Would you suggest that working in TV production is a good route for a would-be Presenter to follow?
It can be, but employers can be wary of hiring people in production roles who make it clear from the outset that they want to be presenters. The feeling is that they won't do the job behind the camera as well as someone else because their focus is in front of it.

To do list

- ❑ Regularly check websites, Twitter and job alerts for job opportunities.
- ❑ Apply for work experience, work placements and training schemes.
- ❑ Attend networking events, seminars, workshops and festivals.
- ❑ Watch TV and list production companies to contact.

Click, read, discover

www.skillset.org – information on careers, training and jobs
www.productionbase.co.uk – film and TV jobs and networking
www.mandy.com – film and TV jobs and networking
www.bbc.co.uk/careers/home – job vacancies and training schemes
www.itvjobs.com
http://4talent.channel4.com
www.geitf.co.uk/thenetwork – the *Guardian* Edinburgh International Television
 Festival, for those who want to work in TV production
www.theunitlist.com
www.rtsfutures.org.uk – events, networking
www.creativetoolkit.org.uk/home

US

www.productionhub.com/events

Part Three
Channel Your Ideas

seventeen
What To Do With Your TV Idea

Ideas are ten a penny, so they say. In a few hours over a mug of coffee or glass of wine you could produce a long list of potential TV programme ideas. The next stage is trickier – how do you turn an idea into a TV programme?

Expert Development Producer Nicola Lees has worked in the media since 1995, specializing in developing non-fiction ideas for television. She's successfully originated, written and pitched proposals for a range of international channels including the BBC, the Discovery Channel, the Travel Channel, TLC and Sky Arts.

Nicola is the founder of TVMole, a website that provides industry intelligence to help TV professionals get their ideas commissioned. Nicola's development credits for presenter-led shows include *Voyages of Discovery*; *Take One Museum*; *Earth: Power of the Planet*; *Journeys From the Centre of the Earth* (all BBC); *Battle of the Geeks* (BBC/Discovery); *Shut Up! It's Stacy London* (TLC).

Annie Davies is a Television Producer, Journalist, and Series Producer specialising in factual entertainment television. Her career has included children's TV, documentary features, lifestyle and arts, game shows, light entertainment, daytime and late night chat and breakfast television.

Programme development, writing proposals and pitching ideas are a particular area of working in television, so here both experts demystify the process.

What makes a good TV programme?

Nicola Lees explains that for an idea to become a TV programme there needs to be a narrative.

> It could be a story that unfolds naturally in the real world, as in observational documentaries or it could be a narrative that is imposed on a subject, such as a factual entertainment-based format. In both cases, there needs to be a premise (a reason for watching), compelling characters, conflict and/or jeopardy (emotional, physical or environmental), some kind of change that occurs (knowledge is gained, lives are changed, competitors eliminated), and a resolution.

Annie Davies adds:

> Broadcasters are looking for ideas that are surprising and new or that put a fresh spin on something that has worked well in the past. They want programmes that are relevant to their target audience, and they are generally looking for a series rather than a one-off as that makes better economic sense. But most of all they are looking for something visually exciting that grabs the viewers' attention and doesn't let go. Create a show that excites the eye as well as the ear and you're on your way. Show people doing things not just talking about them. Remember this is television not radio. You'd be surprised how many would-be programme producers forget that.

What makes a winning proposal?

Annie Davies has developed and run shows for major terrestrial and satellite channels and was Development Producer at UKTV, Flame and RDF Media. What format does Annie recommend for presenting an idea to TV producers or commissioning editors?

> There is no magical formula. But, if the channel or production company you're taking your idea to doesn't provide an online submission form, there are some basic guidelines you can follow to maximise your chances of getting your idea noticed.
>
> Your window of opportunity is a small one. Commissioning editors get hundreds of proposals. Unless your idea grabs them in the first

paragraph it might be in the bin before the second. So keep it short and sharp, clear and concise. It should be three pages at most, including cover page and double spaced in a simple easy-to-read font.

The cover should include the following basics:

- ❑ A memorable programme title encapsulating what the show is about. *I'm a Celebrity . . . Get Me Out of Here!*
- ❑ An attention-grabbing image giving a flavour of the show. If you've got a big name involved, then use a shot of them here.
- ❑ A one-sentence strapline explaining the idea. 'Twelve celebrities battle it out in the jungle for the ultimate prize . . .'
- ❑ Running time and number of episodes e.g. 30 minutes × 12

The main body of the proposal should include:

- ❑ A punchy introductory paragraph.
- ❑ Brief description of content and structure. What will the viewer see?
- ❑ Brief details of presenters and contributors.
- ❑ Brief details of film sequences.
- ❑ Outline of individual episodes if it is a series.
- ❑ Information on key production personnel.
- ❑ An indication of how the programme will be made. For example, it might be shot on location with a single camera or it might be live with a studio audience.
- ❑ And don't forget to include your contact details.

According to Nicola Lees:

The best ideas can be expressed in a single sentence; after reading this single sentence commissioning editors will already know if they are interested in the idea. In reality, most ideas are presented in a one- or two-page written proposal. A professionally presented proposal should contain a title, a one-paragraph synopsis of the idea, a short outline of the narrative / main characters / episode breakdown (depending on the genre), and brief description of how the show will be constructed, for example using archive footage, interviews, time-lapse filming, etc. The number and length of episodes should also be noted, and contact details included. However, it's increasingly expected that a written pitch should be accompanied by a pitch tape – this is particularly true when pitching new onscreen talent.

Who should you pitch the idea to?

With the fragmentation of the TV industry and so many channels to choose from, how do you know where to start? Annie Davies offers the following advice:

> Channel and proposed programme should have the same target audience. Before you contact anyone, decide who your viewer is. Are they old? Young? Male? Female? City boy or retired Colonel? The clearer your picture, the easier it will be to decide what channel they'd choose. Look for channels broadcasting shows on similar subjects to yours then watch them closely. Who are they designed to appeal to? The content, choice of presenter, shooting style and pace can tell you a lot. Does the channel commission original programming or just buy material in? If it's the latter, then they're no use to you. Make sure you check out channel websites too. Many carry details of the target audience and information on the sort of programmes they are currently looking for. Some even have online submission forms.

What are the top tips for pitching an idea?

Nicola Lees feels these are the key points to remember when pitching an idea:

> Pitch a story not the subject area; know the who, what, where, when and why of your story; pitch to the right person at the right kind of company for your type of idea; aim to build a relationship rather than get a commission. And most of all listen, respond positively to negative feedback and be flexible and alert, many commissions come about because of a casual conversation that happens after the formal pitch – if you are too focused on pitching your idea in the way you want to make it, you may miss a potentially more valuable opportunity.

Annie Davies adds:

- ❑ Do your homework and research the channel you are pitching to and its programmes.
- ❑ Know your proposed programme inside out and know how it works.
- ❑ Don't promise what you can't deliver. If your pitch says you can deliver a particular celebrity, make sure you can or you could end up looking very silly.

❑ Be enthusiastic about your idea but listen to suggestions from the commissioning editor. Remember, they know what works for their viewers.

❑ Be flexible. If you've got no previous programme-making experience you will probably be asked to work with a producer or production company the channel already knows. Don't fight it, after all they will be investing a lot of money – they need to know it is being looked after.

❑ Be prepared for rejection and don't take it personally. If you really believe in your idea then repackage it and pitch it elsewhere. Sometimes it's all about being in the right place at the right time.

What makes a winning team?

Presenters, freelancers and people working in production frequently ask whether they should try and go it alone, or is it best to hook up with an existing production company. Nicola Lees advises:

> The TV industry is built on relationships and it's almost impossible to get a broadcaster or cable channel to take you seriously if you don't have an existing relationship in place, therefore it's easier to make the approach via established production companies. The best way to do this is to look at the credits of shows of the kind you'd like to present and find out which production companies are likely to be a good fit – and therefore more receptive to an approach. An alternative would be to sign up to a talent finding service such as http://findatvexpert.com as they have existing relationships with lots of production companies and they will know who is actively looking for new talent at any given time."

Can ideas be protected?

Another frequently asked question is how can presenters with an idea protect their work? Can an idea be copyrighted? 'There is no copyright in an idea itself, only in the expression (such as in writing or filming) of that idea,' explains Nicola Lees. 'Many people have similar ideas but not all of them have the ability to execute them. The best way to protect your idea is to have something that requires expertise or access to someone/somewhere that no one else has, which means that you have to stay attached to the idea otherwise it can't be made.'

'Copyrighting ideas is well-nigh impossible,' agrees Annie Davies. 'By all means put your name and the copyright symbol on your document. But your best bet is to make yourself so central to the programme that it can't be made without you. If you are so close to the subject of the film that they won't work with anyone else, then you're laughing.'

How should you approach a TV company?

Should presenters approach TV companies direct or should they go via an agent or producer? Nicola Lees says:

> If you want to pitch an idea, the best person to approach is the Head of Development in a production company. Not all companies will accept unsolicited ideas, but may still be open to having an introductory meeting if you can demonstrate in a couple of paragraphs why you would be a good fit for the kind of programmes they make (because of your specialist knowledge and/or expertise, for example). Once you've met them and established a relationship with you they may then be willing to discuss your ideas.
>
> In the US it is more usual for an approach to be made via an agent, but in the UK agents will only really get involved once there is an offer of work on the table for them to negotiate.

Can you work on the final production?

Is it possible to ensure that as a presenter with an idea that goes into production you will work on it? Annie Davies says:

> It can be but it isn't always easy. A channel may have a team of preferred presenters who are part of its established image. Or they may be unwilling to risk putting the show in the hands of an unknown quantity. Be prepared to be flexible. But make sure that if you're not onscreen, you still make some money out of it. This is where you wheel in your agent!

Nicola Lees advises: 'Even if the channel insists on having a different presenter on an idea that you originated, there could still be scope for you to negotiate a role on the production, such as being a researcher or consultant. This means that you still get paid a fee and also benefit from learning how productions work behind the scenes.

What about taster tapes?

Nicola Lees says:

> A taster or pitch tape is increasingly expected by broadcasters, especially when pitching new onscreen talent; this is the responsibility of the production company, who are best able to tailor the tape to showcase your skills, demonstrate the idea and fit the channel brief. However, if you are hoping to pitch yourself as a presenter it can help to get something on tape that you can send to production companies if they should ask. The type of tape depends on the kind of presenter you'd like to be: if you envisage interviewing people, it should show you interviewing someone; if you have specialist knowledge, it should show you explaining something; if you are a hands-on expert, it should show you talking as you do something active. An ideal introductory tape would be two or three minutes long and show you talking to camera, talking while doing something active and interacting with other people in some way, and can be shot on an ordinary home video camera. If you have natural talent, it will shine through despite not being of broadcast standard.

Should you put your pilot show online?

Nicola Lees says:

> If you have a skill or knowledge that lends itself to short webisodes – such as cooking or DIY skills – you can just set up your own show and start posting online. This is a good route to practise your camera technique and to build an audience, which will be beneficial when approaching production companies as it provides social proof and will help with the marketing of any future shows that you might be involved with. However, it's extremely unlikely that you will just be discovered; people who have found success and recognition online have typically spent many years patiently uploading hundreds of hours of footage, building their social media profile, interacting with their followers and growing their fanbase slowly but surely. Once they've done that some extremely successful online personalities decide that, even when TV companies come knocking on their door, they'd rather stay online where they have more creative freedom and control over their personal brand.

To do list

Books

Lees, N. *Greenlit: Developing Factual/Reality TV Ideas From Concept to Pitch*. London: Methuen Drama, 2010.
Lees, N. *Give Me the Money and I'll Shoot! Finance Your Factual TV/Film Project*. London: Methuen Drama, 2012.

Click, read, discover

www.tvmole.com – for the latest on which TV projects are going into production
www.rtsfutures.org.uk – runs events on how to create successful programming and talks with industry leaders@tvmole

eighteen
Setting Up Your Own Internet Channel

According to Ofcom around 97% of UK homes have digital TV, 75% of adults have broadband (fixed and mobile), and there are 3.8 million superfast broadband users. We have been empowered to broadcast to the world – literally from our own homes. Creating your own Internet TV channel is a reality.

Nigel Dacre, CEO of Inclusive Digital – a digital media company that specialises in video production, websites and digital platforms, says: 'There's no doubt that the Internet is a fantastic promotional tool for presenters and reporters. It allows programme-makers and channel executives to click on a link and be watching a potential presenter within seconds.'

Anyone with an Internet connection can upload videos to a range of sites such as YouTube, Vimeo, Ustream and Justin.tv. Videos are accepted in a wide variety of formats and you can link to other sites such as Facebook, Twitter and MySpace, show videos privately or share with the world. Online tutorials include how to upload video, embed video in your website, create a playlist, customise and brand your channel, so within minutes you can be broadcasting. According to Nigel Dacre:

> As barriers continue to come down, mobile access improves, and convergence spreads, single items of video content will be viewed in many different ways. I actually think this will increase the relevance and role of presenters – as video items or TV programmes will need strong personalities to stand out in the crowd, and attract cross-platform allegiances.

Case study – Helen Hokin, http://www.foodtripper. com/TV

TV presenters are seizing technology and producing videos to launch TV channels and their careers. Helen Hokin is a lifestyle journalist and broadcaster specialising in gourmet travel. Her short films on her Foodtripper website were so successful that in 2011 she was asked by Travel Channel to deliver seven 60-minute episodes of *Foodtripper* shooting in Maimi, Taiwan, Cyprus, London, Black Forest, Estonia and Grenada. Helen explains:

> I launched Foodtripper in 2009 without video and added a web TV channel www.foodtripper.com/TV almost a year later. It's embedded on YouTube but viewable entirely on my website. The idea to launch my own website came after ten years of magazine journalism in the same field. The TV series and website have grown together and I think that one enhances the other.

By being an expert in her field Helen had a stroke of luck when she was discovered by Travel Channel.

> Around 2006 I was interviewing a celebrity chef on stage at Destinations, a trade show for the travel industry. Travel Channel was there to film the celebrity but after the slot they approached me and asked if I would like to make a few mini pieces for their website. That continued for a couple of years until I launched my own publication, *Foodtripper*. At that point they suggested the concept (gourmet travel) would make a good TV series.

Helen went on to win an award from the Caribbean Tourism Organisation for Best Broadcast in November 2012. Since then she has made two more 60-minute shows in the Hudson River Valley and Northern Portugal for her website.

So, how has embedding video on the web channel helped your business?
I make short video interviews featuring celebrity chefs and other personalities related to the world of food and travel. I also make promotional

videos for food production companies, hotels, restaurants and tourist boards. Most videos are no more than six minutes long, since that's as much as most people are willing to watch about a single subject. The videos are picked up and go viral on many websites all over the Internet. This helps drive traffic back to www.foodtripper.com and keeps visitors with us longer.

Research shows that people spend more time watching video online than reading written features. The online TV channel helps to creates 'stickiness', which is the term used to describe how long visitors stay on a website. The idea is to increase stickiness to entice advertisers – the longer a viewer stays the better the chance of advertisers spending money to promote.

What about the technical and production skills?
I hire camera people and online editors. I upload the content myself once it's delivered to me in the right format. I source and write the content myself and direct on location. I'm not especially technically minded. I think it's more important to have a clear idea of what the content should entail and be able to communicate that clearly to technical experts.

What advice would you give to someone who is considering adding video clips to a website to enhance their business or promote their TV presenting career?
Think about how to differentiate yourself from the rest. Presenting isn't necessarily about promoting yourself, but about telling an interesting story for the viewer as an expert through interviews with other experts. It's essential to write and storyboard the content you plan to film before you start. Source good music. Don't overlook the importance of sound. Don't wait for someone to employ you, take control of your own career by continuing to create and produce interesting and different content.

Helen has successfully made the move from journalist to TV presenter/ producer, but what can you do if no mainstream TV channel for your chosen subject area even exists?

Case study – Karin Ridgers, http://veggievision.com/

Karin Ridgers films short TV programmes for a vegetarian and healthy living audience. Karin's background was in private banking and acting and she lives a vegan lifestyle. After her self-financed pilot TV programme was rejected by TV stations, Karin set up Veggievision in 2004 – prior to YouTube and broadband as we know it.

Karin knew she wanted an Internet TV station; she was aiming to make a channel that inspires and entertains vegans, vegetarians and non-vegetarians too. Before people were used to watching film clips online Karin created http://veggievision.tv and then had to find a way to turn it into an online TV station.

'My areas of expertise are my passion and have become my business,' says Karin. 'As a veggie TV programme was considered too "niche" I decided to set up my own station, and had a long wait for technology to catch up! Veggievision is not a just a website, it's an Internet TV station so the clips are vital. For a while that's all we had!'

Now Karin is director of a vegetarian lifestyle Internet TV station with around 1,000 unique visitors to the site every day. Early video clips were mostly interviews with vegetarians such as actor Joanna Lumley, media personality Jodie Marsh and Irish comedian Sean Hughes. Today the station has contributors from all over the world featuring playlists of entertainment, recipes, festivals and news, plus merchandising, cashback offers with more than 2,000 companies and Veggievision Dating. The station attracts advertising that helps to fund the business.

How did you develop the site from a few clips to a TV station?
I attended conferences, met Internet TV station executives and got a lot of help from technicians. I work with freelancers mainly. I can upload, I do not edit myself, although I have done some basic filming. It is a huge undertaking to do it seriously. I am still learning and technology is rapidly changing.

As far as I can see you cannot be too niche – niche is the way to go, especially online. Launching Veggievision has helped raise my profile, led to writing work, meeting different people, filming with celebrities, given me passes to events that I would never have been able to afford, press trips and more. It is very hard work, however – and non-stop! There are around 5 million vegetarians and vegans in the UK and my aims are to gain more viewers and more awareness.

Nigel Dacre sums up:

> For presenters, YouTube and other sites like Vimeo are excellent; free and high quality. You can control your videos by uploading them to on your own account – remember that you'll lose control of the videos if you send them to other people's accounts. But the upside of being on sites like YouTube is enormous – quickly and cheaply you can ensure that you have a digital showcase for your work, which can be easily accessed by anyone, in any country, at any time.

To do list

❑ Shoot short videos to add to your website or upload to a hosting site.
❑ Create a themed channel of your work.

Click, read, discover

www.youtube.com
https://vimeo.com
www.ustream.tv
www.justin.tv
http://new.livestream.com
www.foodtripper.com/TV
www.travelchannel.co.uk/series-info.asp?series=Food%20Tripper&ID=1454#.
 UxI4QYXgXq0 – Helen Hokin on Travel Channel
http://veggievision.tv
www.youtube.com/yt/about/getting-started.html
http://vimeo.com/help/guidelines

Part Four
Using Video

nineteen
Shooting and Editing

If you need to record video you can employ professional camera operators, sound recordists and editors to deliver a broadcast-standard product with high quality sound and vision, well-composed shots, flattering lighting and smooth edits. There are plenty of freelancers and production companies who can help you create videos, but if you need to use the crew on more than one occasion then costs can mount up.

Many employers, producers and agents are happy with a more DIY approach for showreels and increasingly presenters are acquiring video skills so they can retain control and be more spontaneous in reacting to job possibilities. Presenters young and old are learning how to shoot video, record multiple takes in a variety of locations, select the best shots, edit sound and vision and upload. There are some excellent presenting reels online that have been filmed and edited by presenters themselves, and you don't have to purchase a camera if you have a phone that records good video.

Of course there are risks to the amateur approach, including dodgy camerawork, poor focus, framing and exposure, unclear sound and clunky edits, which can distract the viewer from your amazing performance! It's a judgement call, but there is a trend towards self-shooting and editing as equipment becomes more accessible and less expensive.

When it comes to cameras, there are so many options – it's a balance between your needs and budget. What should you choose – a video camera, a DSLR (digital single-lens reflex camera) that shoots video or shoot on a mobile phone? I spoke to several experts including lighting camera operators and video editors Giles Webb and Evan Brindle, both of whom work in corporate video, to get the latest advice.

Camcorders

Giles Webb says:

> If a presenter wants to buy a camera for showreels I'd recommend an inexpensive digital camcorder. Any of the cameras by established manufacturers like Sony, Panasonic, JVC and Canon that shoot HD video, either recording on hard disk or memory cards, will give decent pictures. Choose one that you can mount on a tripod, and ideally with a flip-out viewfinder that will help you frame better. This handycam type usually has good lenses and zoom functions. Most of these cameras start from about £200, and the price difference will represent the quality of lens, microphone and length of recording if it uses a hard drive. The cost will be higher if the camcorder has an external microphone input. If you can afford it, go for this option and get a decent microphone, as this will make the biggest difference.

DSLR

DSLRs are stills cameras that can shoot HD video. They are very popular with professionals and amateurs because of their filmic quality. 'Canon rules the roost with cameras such as the 5D MKiii, 1D and 7D, but Nikon also produces cameras of a comparative quality such as D4, D3X, D800 and D610,' suggests Evan Brindle. 'These are at the top of the medium budget, but if you want a lower-cost camera that still retains HD video quality and interchangeable lenses you could look at the entry-level cameras such as the Nikon D3100, D7000 and the Canon 1100D, 600D and 100D. Audio for the DSLRs is slightly lacking in quality so you won't want to use the onboard mics.'

Giles Webb adds: 'The reason for choosing a camcorder over a DSLR that shoots video is that DSLRs tend to use larger image sensors which provide a much shallower depth of field, which is a) not appropriate for most presenting situations and b) difficult to handle technically. But, if a presenter already has a DSLR, use it rather than spending money on a new camera.'

Phones

Many phones have great cameras with HD resolution and basic sound recording capability; most modern touchscreen phones or smartphones, such as the

iPhone, Samsung, Galaxy, Sony Lumia and HTC One, fall into this bracket, but check before you buy. Evan says:

> There are plenty of accessories to enhance shooting on a phone, including external microphones, steady-cam rigs, prompting and lens adaptors. Storage can be on the internal drive or card-based, so you can insert a larger memory card to enable longer recording times on phones, for example, when shooting interviews. Generally phones have manual controls so you can set your exposure, white balance and also add effects if required.

The mobile phone accessory market is fast-moving. Phones can shoot 360-degree time lapse on rotating tripod attachments, or in super slow-mo, be connected to table dollies for tracking shots, use stereo sound solutions, and you can even hook up to other phones to create a three-camera shoot.

Giles Webb feels that 'there is no reason not to use a phone camera, as the quality is good enough for most purposes – for showreels it really is the quality of the presenting that is the most important thing, as long as the video quality is acceptable'.

High budget

Evan Brindle continues:

> If you're lucky enough to have the budget then look at the following cameras: Generally Sony is the go-to producer for pro video cameras, with the PMW series of cameras ranging from £2,500 to £55,000. If you would prefer a more DSLR feel but from a camera that is dedicated to video then look at the Canon C100, C300 and C500. These cameras are a hybrid of DSLR and traditional ENG (electronic news gathering) video cameras.

Key points for organising a simple shoot

No matter how straightforward your shoot might seem, forward planning is the key to success.

- ❑ Write your scripts in advance.
- ❑ Use the right style, content and tone for your video and target audience.

❑ TV scripts are best written in a conversational style, talking in a friendly way to the viewer.

❑ Memorise your scripts thoroughly to avoid wasting time on the shoot.

❑ Research your guests, locations and topics in advance, confirm all arrangements, the aim of the shoot, meeting points, mobile phone numbers in case of travel delays on the day.

❑ Recce your locations before the shoot to check directions, noise, parking, toilets, permissions needed, cafés, best views and angles for shots, shadows, closing times of venues, etc.

❑ Choose appropriate clothes to wear, with changes of costume where necessary.

❑ Book a hair and makeup artist for the shoot, or be responsible for your own look. It can be very reassuring to have someone else take care of your appearance, as you may not notice a shiny forehead or hair out of place until you see the edit.

❑ Calculate how long you think you will need to shoot each sequence, and create a schedule for the day. Remember, things often take longer than you think they will.

❑ Obtain release forms / written permissions from all contributors and interviewees on the shoot day.

❑ Check the weather for the shoot day.

❑ Make sure you (or the crew) have all the kit you need.

❑ Have some spare cash – very useful when there are noisy workers or gardeners (you might like to suggest they take a tea break while you are shooting!).

❑ Check the recordings back before you leave each location to ensure you are happy with the result.

❑ Clearly label the recordings and keep them in a safe place until the edit.

Key points for recording video

The aim is to bring back the shots you'll be happy with (and avoid a reshoot!).

❑ Check your kit before you leave for a location. Are your batteries charged? Do you have enough storage to shoot everything?

❑ As in any photography, the subject must be lit by a lamp, a light source or the sun.

❑ Bright sun can cause problems if you shoot directly towards it, so use it as your main light source and shoot away from it. If it's grey and dull, you

could invest in a reflector to use the available light to create a more pleasing image.

❑ The white balance has to be set; this balances the colours in the image, so the face does not have a non-flesh coloured hue that has bled from other colours in the shot. Most cameras have auto white balance.

❑ The shot has to be in focus. Zoom all the way in on a shot, focus until sharp, then zoom out to the desired framing. Using auto focus is always risky as focus may slip and not stay focused on the presenter's face.

❑ Check exposure. Make sure the presenter's face and eyes are lit, in either natural or interior lighting. The image should be exposed so that the face looks right – most modern camcorders will attempt to handle this for you. A little 'catchlight' in the eyes will help them sparkle.

❑ Frame the shot nicely – and interestingly if possible. If it is a medium close-up, the classic head and shoulders shot, try to put the eyes about one-third of the way from the top. If a presenter is talking about something behind them, make sure we can see it.

❑ If the presenter is physically expressive, or using big gestures, don't frame the image too tight – give them room to move. It's much more comfortable to watch.

❑ Understand the 'rule of thirds', which is not a rule but a guide. It is a basic artistic concept that puts points of interest on imaginary lines one-third or two-thirds across or down a picture. Camera viewfinders may well have functions that help you with this.

❑ Use a tripod if you can. Wobbly moving pictures may not be comfortable to watch and may detract from the object of the exercise, which is promoting your presenting skills.

❑ Usually the tripod is set at eye-level, so the presenter is looking directly at the camera on the same level, not slightly up at the camera or slightly down.

❑ If using the camera handheld, avoid using excessive zoom as this will make the picture unstable, and be more difficult to focus.

❑ Take inspiration from good work you have seen. There is no harm in copying the style of something that works well.

❑ Most importantly, think what you want it to look like before you start shooting. If you are going to edit it, shoot different takes in different shot sizes so you can cut from one part to the next. Ideally shoot some cutaway shots, something relevant to the piece, that can mask edits from different takes of the presenter.

❑ If you're not happy with something stop and address it – not everything can be fixed in the edit.

Key points for editing

Video editing software may or may not be included in a laptop you buy, but it can be freely or inexpensively obtained. Windows Movie Maker is currently free, and iMovie for Mac is around £10 from the App Store. There are several apps for editing on phones.

These types of non-professional applications are designed to be easy to use – and they are once you get going. They are also capable of producing great results. It may take a while to get started, but there are lots of tutorials online, and they can be really helpful step-by-step guides to the software.

Final Cut, Premiere Pro, Edius, Vegas, iMovie, Movie Maker, Avid, After Effects, Motion – these programmes all enable you to import footage, edit it and then send it off to be uploaded or made into a DVD, etc. Most editing packages follow the same principles; it depends on budget and how you find working with certain software.

- ❏ Keep the edit simple.
- ❏ Allow the presenting to do the work – fast cuts and lots of music may look and feel exciting, but they are actually showing off the editing rather than the presenter's skill – think about the purpose of the video, and who will be watching it.
- ❏ Put as much effort into the sound as the video – try to get the levels from different takes balanced so there aren't any big jumps in volume.
- ❏ Do use music, but only if it adds something, and make sure is doesn't overpower the performance. You should also ensure that it is legal for you to use it. There are lots of royalty-free production music sites that offer music at a very reasonable price, such as Stock20, Audio Network, Premium Beat, Audio Jungle, or sites such as http://ccmixter.org that offer music for free on a Creative Commons licence.
- ❏ Don't make the video too long – just long enough to show what you can do. Remember, your target audience may be watching it on their phone. When it comes to reels, less is more, aim for two to three minutes maximum duration.
- ❏ Know your footage, make sure you know what you're dealing with in relation to its format, resolution, etc. This may be footage that needs to be transcoded (changed from one format to another) for editing purposes.
- ❏ Be organised – make sure you set up a workflow that enables you to work with security. Don't keep your footage, sound, and graphics all over the place, on different drives, etc. Keep all your media together.

❏ Backing up is vital – make copies of your media, projects, etc., and keep these on an external drive apart from your main computer system. There's nothing worse than losing weeks of work.
❏ Learn how to manipulate the image contrast, colours and sound levels.
❏ The more knowledgeable you are, the better the piece will sound and look.

Uploading

When your video is finished what are the key points to remember when uploading to platforms such as YouTube or Vimeo? YouTube and Vimeo accept video files of varying sizes and lengths, so check their requirements.

❏ Follow the compression guidelines set out by YouTube or Vimeo to get the best results.
❏ Upload in HD if you can – the video hosting sites will handle smaller versions (lower resolution) for you. YouTube, Vimeo, etc., will normally play out at a default resolution based on the viewer's bandwidth, so for slower Internet connections it might play at 360p, or faster will play at an HD resolution. Upload the highest resolution you can and let the video platforms take care of the rest.
❏ Title the video, and use appropriate keywords and description that can get your video found in a search.
❏ Decide if you want to make it public or private, and whether you want to allow or disable comments on your videos.

To feel more confident about producing your own videos there are countless training courses in video recording, short courses, adult education, further education colleges, universities, free online advice and tutorials if you want to take it further and increase your knowledge.

Alternatively you could find a professional camera operator or video crew to help you, or TV and film students who would be happy to gain more experience. Have a look at your local colleges and contact the Media Departments as a starting point, but there is also a lot happening online.

Making videos can be done relatively easily and cheaply. But if you really want a professional result, think about using a professional. Paying an expert to make you look and sound as good as possible may be more cost-effective than spending lots of money on equipment.

The shared checklists and resources for shooting, editing and recording sound are at the end of the next chapter.

twenty
Audio

Professionals Giles Webb and Evan Brindle, both experienced in video record-
ing and editing, agree that sound, not video, is the area of concern. Amateurs
often forget about sound. If a video picture is slightly out of focus, overexposed
or out of sync, viewers can carry on watching and follow the story. But, if
sound is badly recorded we tend to wince and switch off. It is relatively easy to
fix visual problems in the edit, for example, by cutting away to another shot,
by changing the exposure to correct the colour, or by resizing the frame to
improve the composition; if sound is poorly recorded or distorted it can be very
difficult or impossible to salvage.

'Sound is more important than pictures,' says Evan. 'If we hear an interview
but don't see it, we can understand what's being talked about. If we only see
images, then we have no idea. So having clear, good quality sound is always the
aim. Invest in something that is going to provide you with the best quality you
can afford.'

Try to record the best possible sound on the shoot, and consider it as
carefully as the pictures. Don't fall into the trap of thinking that you can sort
the sound out at the edit. Giles Webb agrees: 'Good sound quality is just as
important, if not more so, than decent pictures. You can actually get away with
pretty average pictures if the sound is good, but poor sound will detract from
any video.'

Experts advise that you should not use the mic on the actual recording
device; that is, do not rely on built-in or onboard mics on mobile phones or
DSLR cameras, although prosumer or professional camcorders have mics that
can have acceptable quality. So, when buying or using your camera, plan how
you intend to record sound and what external mics, connections, adapters and

cables you may need to avoid poor quality audio. There are many different types of mic you can use, but most are designed for specific recording situations. As a presenter making a reel, you will mostly need mics to cope with pieces to camera and interviews.

There are two types of personal mics, wired or wireless. A radio mic is wireless and works by using a transmitter and receiver to send sound to the camera or sound mixer so that audio is recorded directly with the video. The mic is usually attached to the collar, tie or neckline and is visible on news-readers and TV presenters in many situations in studios or on location. It is used when presenters talk to camera and need to move freely, but can also be used when presenters are seated or standing in one location. The presenter can be some distance away from the camera, depending on the strength of the signal.

This small mic is usually omnidirectional, which means it picks up sound from all directions. A foam windshield can be added to minimize wind noise and reduce vocal 'plosives' on hard consonant sounds. Some sound supervisors place the mic upside down – it still works whichever way it is placed – to avoid these 'popping' noises that can occur with animated speech. The cable connecting the mic to the transmitter should be hidden by feeding it underneath your shirt, jacket, top or dress, so when presenting make sure you wear something practical. Don't be the nightmare presenter who arrives wearing materials that cause interference on the mic (such as a scarf that causes a rustle). The transmitter pack can be placed out of vision attached to a belt, waistband or inside pocket. You may have noticed some female presenters wearing the pack on the back strap of a dress if they do not have a waistband. The aim is to keep all kit and cables, except the mic, out of vision.

A radio mic can be expensive. Giles advises: 'You will probably need a licence from Arqiva PMSE (Programme Making and Special Events) to use it. Avoid second-hand ones as they probably use frequencies that are no longer legal.'

You can also use personal mics, lapel mics, clip mics or lavalier mics that are wired. They are usually attached to the collar, tie or neckline and can be used for pieces to camera or interviewees. Unlike radio mics, the wired mic has a cable so you will not be able to walk around freely as you will be connected to the camera, and if you are in a TV studio your cable may connected to a sound patch in the wall. So these mics are best used in setups where you are seated or stationary, where you are close to the camera or easily connected to the camera, such as a piece to camera or interview.

A handheld mic is useful for vox pops or interviews on the move, as you do not need to mic up interviewees in advance. They can be wired or wireless. Some are omnidirectional, that is, they pick up background noise, which might

be useful if you want to hear the ambience, for example a nearby stream or funfair. If you want a cleaner sound for the voice, without background noise, use a directional mic that picks up the sound from wherever you point the mic. It is acceptable to see these mics in vision. To reduce wind noise, use a windshield.

Check which audio input connection your camera has; for example, mobile phones and DSLRs have a 3.5mm headphone jack socket, but most prosumer and professional cameras have XLR inputs.

Mobile phone built-in mics are designed for phone conversations, so for showreel purposes it is advisable to invest in an external mic. A Rode smartlav mic connects to a phone or tablet via the headset/headphone socket to record audio and is used with an audio app (Rode Rec App). Or, if you are using an XLR cable use an iRig pre which is a small pre amp that plugs into the phone giving you one XLR input for any professional microphone.

For high-quality audio on a DSLR rather than using the built in mic you can record the sound separately on an external audio recorder such as the Zoom H4n. However, this audio will then need to be synced in post-production to match the sound to picture, which is another process to master. Shooting and editing are much easier if video and audio are recorded together. The Tascam DR 60D is similar to the Zoom H4n and attaches to the camera itself giving you audio and video in sync or you can record sound into the Tascam itself, but again synced audio is better. It provides high-quality sound recording and is designed for DSLR filmmaking, fitting neatly on to the tripod.

The lower end of the mics market generally produces a lower quality sound, such as hiss, unwanted noise or poor frequency response, so when buying a mic make sure you test the mic with your camera before you buy.

Key points for recording sound

There are a few simple things you can do to improve the quality of sound recording. Checking, rehearsal and planning will help to eliminate audio disasters.

❑ Listen to what is being recorded on good quality headphones.
❑ Always aim to get the microphone close to the sound source (normally the presenter's mouth). This is particularly important in a noisy environment, outdoors for example. Remember, the further away the mic is, the more background sound you will record. A handheld mic should not be obtrusive though.

❑ Mic placement is important. A radio/clip/personal/lavalier mic should be about level with the second button of a shirt; a handheld mic about level with the breastbone; and a mic on a stand just out of frame above or below the presenter.

❑ If you are using the internal camera mic, or a camera-mounted mic, don't shoot from too far away, and ensure the presenter is using enough voice to be heard clearly.

❑ When using a mic, there is no need to project your voice.

❑ A good directional mic will reduce the ambient noise of the surroundings you are in.

❑ If using a handheld mic, keep it at a steady distance from your mouth – moving it will play havoc with the levels.

❑ It may seem obvious, but make sure the microphone is pointing at the mouth of the person speaking.

❑ Try and avoid recording in windy situations. If you do, you'll need a specialist 'fluffy' type windshield such as the Rode Deadcat or a Rycote windshield.

❑ If you are filming near a noisy sound source, a stream or a building site, make sure that it is visible in shot, or shoot some cutaways of the sound source so the viewer can make sense of the noise.

❑ Preferably eliminate any unwanted sound before you start; for example, air conditioning or traffic. You may have to change locations to find a more suitable place.

❑ Do a sound check first before recording. Talk at the same level you would when you are actually doing the piece to camera and adjust the levels accordingly.

❑ If you are monitoring audio levels the presenter's audio level should be between –18db to –10db. This is a safe zone for level.

❑ Use the right mic for the situation, so don't use a personal mic for a sit-down interview when the guest is wearing noisy material and is shuffling around all the time, use a directional mic and mount it on a stand or on your camera.

❑ If you record audio on an external recorder, such as a Zoom H4n this will need to be synchronised in the edit. Some editing software, such as Final Cut Pro X can do this automatically for you. If not, it is worth using a simple technique such as a handclap at the start of the audio and video recording, which will help you line up the sound visually in an editing program.

You can also record voiceovers for your videos – find a quiet place, preferably a small area without echo.

Online tutorials are a really valuable source of information on cameras, mics, lighting, shooting, editing and uploading your material. The advice here can only be a starting point – the more you know the better your videos will be. Whatever your budget you will find something to suit your needs, but you tend to get what you pay for.

To do list

- ❏ Research software, equipment, self-shooting techniques and professional crews.
- ❏ Practise shooting and editing your own footage.

Click, read, discover

Broadcast and professional video production equipment purchase/hire

http://cvp.com
www.prokit.co.uk
www.proav.co.uk
www.visuals.co.uk
www.libraprobroadcast.co.uk/index.asp
www.pmse.co.uk/home.aspx – for radio mic licences

Tutorials

www.youtube.com/yt/creators/tutorials.html
http://vimeo.com/categories/education/tutorials
www.bbc.co.uk/academy
http://howto.cnet.com
www.izzyvideo.com
www.youtube.com/yt/about/getting-started.html
http://vimeo.com/help/guidelines
www.lynda.com – subscription tutorials

Find a crew

www.productionbase.co.uk
www.theknowledgeonline.com
www.mandy.com
www.webbfilms.co.uk
https://shootingpeople.org/home

Part Five
Using New Media

twenty-one
YouTube and Blogs

As well as producing your videos and showreel material, being able to use new media effectively is another part of your toolkit. The key to raising your profile is to create high-quality material that a community can like and share. According to Gavin Stewart, Principal Lecturer in Media Arts in higher education:

> The only certainty of the new media is that we do not know exactly what the next development will be in the field. However, experts argue that we will see a move to a more intimate, personal and location-based model of consumption based on smartphones and devices like Google Glass. Regardless of how the technology develops, people will continue to want high-quality experiences that provide them with a sense of participation, an opportunity for expression, as well as for entertainment and information.

Created in 2005 by Chad Hurley and Steve Chen as a way of sharing video online, YouTube was bought by Google in 2006 for $1.65 billion. According to YouTube statistics, more than 1 billion unique users visit YouTube per month and 100 hours of video are uploaded every minute. Today one of the most popular videos includes *Homeless Lottery Winner* with more than 9 million views in just two days. Tomorrow there will be another chart-topping video, and so on.

The trend has developed from individuals uploading one-off eccentric moments to presenter-led channels that feature a series of videos building up huge followings for the creators. Many YouTube channels have bigger audience figures than TV programmes or TV channels, with millions of subscribers.

Vloggers or video bloggers (from the words web log, video log) often using only their bedrooms or gardens as locations for recordings, build up relationships with their audiences on an international scale. It's democratic, anyone can become a blogger or broadcaster and, unlike traditional TV, the creators get instant feedback from their viewers in the form of comments or likes. Online analytics give the creators information about the location and demographic of their viewers so they know more about their audience than traditional forms of TV audience research.

Success is down to personality and content. Previously unknown youngsters have been catapulted to the top of the YouTube charts with their quirky views on life, chatting to the viewer about virtually anything. Charlie McDonnell has been broadcasting since 2007 and with more than 2 million subscribers to his channel charlieissocoollike, he was the most watched in the UK. Having built up this following, Charlie is now making a feature film. Launched in 2006, Dan Howell's channel danisnotonfire is another UK YouTube sensation with more than 2 million subscribers. Since 2013 Dan has presented *The Request Show* on BBC Radio 1. JacksGap channel launched in 2011 has nearly 3 million subscribers, and around 1.5 subscribers tune in to Pixiwoo.com for simple and compelling makeup tutorials. These are more than channels – they are businesses. The YouTube partnership programme enables those with a significant following to host adverts and receive payments for the advertising.

YouTube success stories include SBTV, the UK's leading online youth broadcasting channel featuring music, lifestyle and the urban scene, founded by Jamal Edwards. Jamal was the subject of a Google Chrome advert and Channel 4 documentary *From Bedroom to Boardroom*, which charted his rise from London estate to offices in the West End. Entrepreneur Jamal started by broadcasting low-key home videos that attracted big name Musicians; SBTV has more than 6 million views per month and more than 400, 000 subscribers.

YouTube and Google are investing in the most popular creators by establishing YouTube Spaces in London, Tokyo, New York and Los Angeles. The spaces allow YouTube partners to collaborate with each other – animators, musicians, filmmakers, journalists and comedians – to learn new skills and develop their ideas, which in turn may lead to higher advertising revenue. You can investigate becoming a YouTube partner, which allows you to monetise your content through adverts, paid subscriptions and merchandising, as long as you haven't broken YouTube terms of service and your content is advertiser-friendly.

To create your own channel all you need is a camera and access to the Internet. Start filming your videos and upload to YouTube or Vimeo, etc. If you don't have access to editing software then YouTube provides some for you

when you upload your content. It takes confidence but it is a way of being proactive and taking things into your own hands. Vloggers, people who blog with videos, sometimes choose to stay in the YouTube arena, in control of their own broadcasting, but without doubt setting up on your own can get you noticed – from there you might gain representation and work on mainstream broadcasts.

To achieve a faster growth you can set up YouTube networks which are multiple channels linked together. The Young Turks is a multi-award-winning US-run YouTube network that has several channels and shows that combined have nearly 70 million views per month. Joining a YouTube network has pros and cons – some benefits include increased audience and access to studios; however, you may be involved in lengthy contracts so consider if this is part of your long-term plan.

Another successful YouTube network is run by the vlogbrothers, John and Hank Green, based in the US (John is *New York Times* bestselling author of *The Fault in our Stars*). Their network of 25 channels and more than 6 million subscribers has nearly 800 million views. Their YouTube channel's eclectic mix of video topics range from 'understanding the Central African Republic' to 'cooking macaroni cheese with a three-year old'. The channel was set up in 2007 and their early videos were little more than public correspondence between the two brothers. Now they own a record company, DFTBA (Don't Forget to be Awesome) and have founded VidCon, an industry conference for creators of online video content.

To increase your digital footprint, collaborate with people who have more subscribers than yourself. Andrew Wilson, Founder of Cloud9 Management Ltd talent agency, says: 'Numbers talk, if you've got a million subscribers on YouTube broadcasters will be queuing up.'

If you have a programme idea that you believe in, but cannot raise broadcast interest or finance, then start the ball rolling by creating a pilot show online and pick up momentum for the project. US drama series *The Misadventures of Awkward Black Girl* launched online and gained a huge following. Its success encouraged other US and UK programme-makers with series such as *Brothers With No Game* and comedy drama *All About the McKenzies* both originally web hits, now showing on TV. Presenter Amanda de Cadenet appears on Conversation TV – an interview series and website. David Mitchell, star of Channel 4 sitcom *Peep Show* and BBC sketch show *That Mitchell and Webb Look*, uses YouTube alongside mainstream TV for his work. *David Mitchell's Soap Box* can be seen on Channel Flip, which has more than 22 million subscribers.

The lines between TV channels, online channels and websites are becoming more blurred as content moves from one broadcasting platform to the next.

YouTube websites, blogs, video logs and more – these are all available to presenters who want to express their ideas and start broadcasting their work.

Case study: Becki Burrows, Creative Director of ohDearyme, award-winning blog

Becki Burrows trained in interactive media, worked for mainstream TV as a researcher and producer, and now produces and presents her own material. The content Becki has created has gone on to win several competitions including the Pepsi MaxCast bloggers prize in 2007, Vodafone Myspace Reporter in 2008 and See Africa Differently in 2011. Also in 2011, Becki won the *Company* magazine competition to be the Brit Girl 2012 at the Brit Awards. In 2013, she was selected for the Nokia Lumia competition to compete with five other bloggers to submit a report on the *Man of Steel* premiere, which she won.

How did you get started?
OhDearyme started off on a £30 video camera and it's nice to see how it has evolved over the years. I did a lot of work for free, and interviewed artists that hosted my videos on their platforms too.

What do you recommend to raise your digital footprint?
Getting on as many platforms as possible, doing and taking guest blogs can be an option if it's relevant to your brand.

How important is it to have a website?
Websites are pretty much accessible to everyone. However, it is good to have your feet on as many platforms as you can. Wherever you think your audience might be. Keep it simple, accessible and keep in mind who you want to be accessing your work.

How can the technically challenged TV presenter on a limited budget create a website?

Currently there are several free options including WordPress, Wix, Moonfruit and Weebly. These are simple ways to set up a website offering themes and

templates that you can customise with your own look, designed to be used by non-technical people, and small businesses. There is a wealth of information on the web in tutorials, podcasts and videos, so try Googling 'web design tutorials' to get started. If this takes you out of your comfort zone then you could hire a web designer, or try skill-swapping.

You can either load your clips on to YouTube so they are searchable or embed them on your website via the YouTube share link, if hosting space allows it. Some would advise that your videos should definitely be embedded in your site, as you want your visitors to stay with your brand and not be directed to another site where they may be distracted by other videos. Others feel that if your videos are on YouTube you can direct traffic to your site from there. Whatever you decide you should control the content that you upload. When you have created your site / channel you can use social media to promote it and drive more visitors your way. Gavin Stewart advises:

> Sociologists of the new media tell us that users value participation, authenticity and community engagement. Presenters can make use of this desire by acting as a figurehead and storyteller for the community. However, they should also be aware that they should impose limits on what they share and how they share so they do not provide too much of themselves to the wider public domain.

To do list

- ❑ Research YouTube channels and how to create your own.
- ❑ Research YouTube partnerships, networks and YouTube spaces.
- ❑ Build a website.
- ❑ Start a blog.
- ❑ Research new media techniques to build your brand.

Click, read, discover

www.youtube.com / user / danisnotonfire
www.youtube.com / user / pixiwoo
www.youtube.com / user / JacksGap
www.youtube.com / user / charlieissocoollike
https:// / support.google.com / youtube / #topic=4489102 – YouTube help centre

www.theconversation.tv
http://ohdearyme.com

US

www.youtube.com/user/TheYoungTurks
www.tytnetwork.com
www.youtube.com/user/vlogbrothers/featured

Part Six
Using Radio

Radio can play a very important part in a TV presenter's toolbox and broadcasting career, so these chapters contain interviews with key radio producers and presenters, followed by a comprehensive checklist and resources.

twenty-two
TV and Radio

There is a well-worn path from radio presenter to TV presenter, and back again, with many transferable skills between the two media. In common there are:

- chat shows, interviews
- documentaries, features
- sports programmes
- music
- quizzes, entertainment, comedy
- news, weather, travel
- current affairs, debates, vox pops
- Continuity Announcers
- competitions
- drama
- live events, outside broadcasts.

Both TV and radio presenters need to conduct research, create material, write scripts, interview, be interviewed, work with guests and production teams, be briefed by Producers, hit deadlines, talk to time, work in a multi-skilled environment, have good vocal abilities, adhere to broadcasting codes and have excellent performance skills.

Broadcasters in both media are increasingly working in tandem, with a merging together of output; for example BBC News is on radio, on TV and online, and some radio programmes are now on TV. BBC Radio 4's business conversation show, *The Bottom Line* can be viewed on the BBC News Channel.

Presented by Evan Davis, the TV show is a fascinating hybrid of TV and radio, set in the radio studio, where presenters and contributors ignore the camera, yet it is still compelling viewing and listening.

Jonathan Marsh is a Lecturer in Radio and an established BBC Radio Producer currently researching his Professional Doctorate in DAB radio in the UK. He says:

> Media technology is converging. Listeners can now watch live radio programmes as broadcast on selected radio stations, such as BBC Radio 5 Live website. Online users not only hear the radio programme, but can witness the behind-the-scenes operations of a live radio station, enabling the listener to feel more involved in the intimacy of radio.

Lawrie Hallett, Senior Lecturer in Radio, researching his PhD in Community Radio at the University of Westminster and formerly part of the Radio Team at Ofcom, says:

> Constraining the vision element to a radio talks format works for factual, business programmes where the verbal discussion element is key. However, it wouldn't work in the same way for, say, a film review programme, as the viewer would, of course, want to see the film clip, not just hear it. Vision is the primary focus in TV, sound is the sole focus in radio, and that will always be the difference.

Radio 1 has its own YouTube channel featuring bands, DJs and performances recorded live on radio yet captured on multi-camera. Dellessa James, Producer at BBC Radio 1/1Xtra, has been working with award-winning DJ and TV presenter Charlie Sloth for two years. Their show won the Bronze Radio Academy Award 2013 for Best Entertainment Programme. As well as an award-winning radio career, Charlie also presented Channel 4's *House Party*. Dellessa James comments:

> Radio and TV are merging together as the industry evolves. Most radio stations have a multi-platform visualisation department and YouTube channel where listeners can relive exclusive and popular content. Many radio stations now film their biggest radio interviews and also stream them across the Internet for listeners to download and watch at a time that's convenient for them. Many TV presenters use radio as a way of connecting to audiences directly and getting their personal tastes, brand and opinions across, which they don't tend to do in TV.

Emma Barnett – presenter LBC Radio 97.3 FM, Women's Editor at *The Daily Telegraph*, winner of the Media Award for Women of the Future 2013 and the Arqiva Award for Best New Radio presenter – agrees that TV presenters can use radio to enhance their career and build up a profile. 'I think it is a great space for deeper and more in-depth work. It is also helps TV presenters connect with the audience and hone their personable skills.'

In terms of performance skills, there are many similarities between TV and radio. TV presenters should talk to one viewer, radio presenters to one listener, typically their mum or best friend. Both types of presenters should be warm, friendly and be themselves. A TV presenter must not 'dry' on air, that is, run out of material to say, but should fill the screen time as required. In the same way, radio transmissions cannot have radio silence, and the presenter must be able to confidently chat to the listener without running out of things to say. Of course a radio presenter can always play a music track to fill time, and can read from a script or notes without the listener being aware – they can even present without makeup or the right clothes – but key for both presenting genres is to know your audience and display excellent communication skills.

On radio, the presenter paints a picture for the listener in words. Ann Kaye, a former BBC Radio Producer and presenter, says: 'The old cliché, "pictures are better on the radio" comes to mind; you lose the visual and have to do it all yourself.'

KISS FM's Breakfast presenter Melvin O'Doom works across TV and radio. He won Gold at the Sony Radio Awards in 2012, appeared in *Dick and Dom in da Bungalow* and *The Slammer* and hosts a range of TV music shows. How does Melvin approach his performance on TV and radio? 'Radio sharpens up live skills. On radio I have high energy, as opposed to my more usual relaxed self at home. I paint pictures with words for the viewer and describe every last detail of a premiere or event. On TV, I use my face, just a look, or I do something silly.'

Neil MacGregor, Director of the British Museum, created 100 15-minute programmes each featuring an object from the British Museum in the radio series *The History of the World in 100 Objects* on BBC Radio 4 in 2010. In every episode he described the object with such clarity that listeners could imagine it clearly for themselves, even though the object was not visible to them. TV presenters also need to be able to describe a scene, even if it is visible to the viewer; they need an excellent vocabulary and the ability to put themselves in the viewers' situation, to answer the questions in the viewers' minds.

Although there are strong transferable skills between TV and radio, Lisa Kerr – Media and Communications Consultant and former award-winning Producer and presenter for Classic FM – advises:

Radio and TV are very different skills. TV presenters often assume that radio is easy, but it definitely is not, and there have been some spectacular failures as a result of this assumption. You need to be much more self-sufficient in radio since you are often the presenter, producer, director and researcher all in one. I'd say that you should only go into radio if you really want to be there – not use it as a stepping-stone. It might become that, but if you go into it with that objective, it will be apparent to everyone around you and you'll make no friends!

BBC TV and Radio presenter Julian Worricker says his background is very much in radio and that remains his first love. 'I've always said I'll do TV *as well as* radio, but never *instead of*. People who move between the two tend to do radio first, and that works better in my mind. I'm often suspicious of people who've done TV and then assume they can do radio . . . only to find that, actually, they can't. Radio is surprisingly exposing of the bland.'

Not everybody is equally suited to TV and radio, as John Byrne, Entertainment Industry Career Adviser at *The Stage* newspaper, explains:

There are lots of reasons for this that are not always in the individual's control: 'look', voice quality, that certain *je ne sais quoi*. There have been very successful crossovers both ways, but also some less than triumphant ones, so if after giving it a good go radio just isn't for you maybe consider a different way in to TV . . . and if TV doesn't work out, it might mean you are a radio star in the making.

twenty-three
The Breadth of Radio

It is said that radio has a greater audience than TV worldwide. Radio is available in so many forms – national, local, community, hospital, prison, student and web-based – and on so many different platforms – analogue, digital, Internet, satellite and cable. You don't need a radio to be able to hear it – use a mobile, computer, app or TV, and wind-up radios are available for remote places without power. According to Radio Joint Audience Research (RAJAR) in the UK we listen to around three hours of radio per day, or around 21 hours per person per week.

The way we consume radio is changing. Jonathan Marsh, Lecturer in Radio and a BBC Radio Producer says:

> Radio listeners can access a wider range of material, such as online podcasts, programme information and blogs, and can now formulate and create their own bespoke radio programme schedule to suit their individual needs, personal tastes and requirements. The Internet has enabled the humble radio to evolve and transform. The radio listener is now the radio viewer and the radio consumer.

Working for smaller local, community, hospital or student stations can lead to employment on a national radio station. However, before you start your search for a radio job it might be useful to understand the differences between the licences, and to discover where the potential jobs are.

The BBC has five analogue national radio networks, Radio 1, Radio 2, Radio 3, Radio 4 and Radio 5 Live, each with its own style and target audience. The BBC also runs five digital-only radio networks, 1Xtra, Radio 4 Extra, Radio 5

Live Sports Extra, 6 Music and the Asian Network, and delivers BBC World Service to the UK via digital radio. BBC Radio includes Nations and Regions; that is Scotland, Wales, Northern Ireland and 40 local radio stations in England. Across the world, BBC World Service radio transmits in English and 27 other languages for international listeners.

Ofcom licenses all UK television and radio services outside the BBC, and its broadcasting code sets out the rules for all the stations it licenses. According to Ofcom, in 2013 there were 27 national radio stations, 338 UK local radio licences and 207 community stations. A full list of all Ofcom-licensed radio stations can be found on its website.

Is there a difference in presenting styles on different services? Lisa Kerr – Media Consultant and former Producer and presenter on Classic FM – explains:

> In the commercial sector, quite simply, employers are looking for presenters who will increase audience and therefore bring in revenue. Presenters need to ask themselves, why would someone want to listen to me? What do I have to say? What can I offer?

Community radio

Dr Janey Gordon, Principal Lecturer at the University of Bedfordshire, explains:

> In the UK, local radio is either BBC local radio and part of the BBC, or commercial local radio, which has a commercial licence from Ofcom that they have paid for, for a certain period. The geographic locality and what they do in terms of content will be defined by the licence. Community radio is not-for-profit, serves either a community of interest or geographic area and will typically have a transmission area of about 5km from the transmitter. There are slight variations to this. In addition, it is tasked with demonstrating social gain.

Janey is also Project Manager at Radio LaB community radio station for Luton and Bedfordshire. There are hundreds of licensed community radio stations in the UK, from The Super Station in Orkney to Radio Scilly. Some regions have clusters of community radio stations; for example, Greater Manchester has Salford CR; All FM, South Central and East Manchester; Wythenshawe FM; Tameside CR; Pure, Stockport; Bolton FM; Peace FM, Hulme; North Manchester FM; Gaydio, Manchester; and Unity Radio, Central Manchester. In Greater London there are several community stations including Desi,

Southall; Hayes FM, Hayes; Bang, Stonebridge and Harlesden; NuSound, Newham; Resonance FM, Central London; Voice of Africa, Newham; Westside CR, Southall; Rinse FM, Inner London; Reprezent, South London; Insanity, Egham; and Betar Bangla, Tower Hamlets. Ofcom lists all the licensed community radio stations and their areas so the information is transparent and it's easy to research where you could apply for work.

Other types of radio service

There are also hundreds of cable and satellite radio stations and increasingly stations that broadcast only on the Internet. Not all radio stations are permanent broadcasters. Restricted Service Licences (RSLs) are temporary short-term licences usually for a few weeks, to cover an event or series of events. For example, Jamrock Radio in Luton is on air for Black History Month, Radio 5 in Coventry is on air for Diwali broadcasts, and Nitro FM in Podington, Northants, is on air for a season of drag racing events.

Long-term RSLs also exist, used by some British Forces Broadcasting Services (BFBS), some hospital radio stations, and some colleges and universities. Again, information about existing and upcoming RSLs is available on the Ofcom website, along with contact details for the stations.

So the radio scene is complex, with hundreds of stations you could apply to. That said, it is still a competitive market and you will need to prove yourself to get a foot in the door. Lisa Kerr sums up:

> It's really competitive, but there are very few real talents out there. I honestly believe that people who have talent, determination and creativity will break through. That determination has to be relentless and the creativity isn't just about the content you produce, but the way in which you go about making connections and building a network that will further your career.

twenty-four
Radio Training and Skills

Dellessa James, Producer at BBC Radio 1/1Xtra, suggests:

> At the start of your career, I would recommend a basic TV or radio course (depending on what you prefer). This will give you an insight into the job and the roles around it. You will also meet people who are interested in the same industry as you and hopefully you will meet up-and-coming directors, producers and future contacts. After the course is completed, it is vital you gain as much experience as possible.

There is a huge array of radio training and this guide can only mention some of the training on offer. Creative Skillset, the sector industry body that supports skills and training for the creative industries, has plenty of resources on its website, including information regarding funding, apprenticeships and careers. From time to time they have funding schemes for freelancers working in the industry who wish to develop their technical knowledge and training. Creative Skillset recommends routes into radio, collaborating with the BBC on events such as Fast Train, with workshops, seminars and training opportunities.

The BBC Academy offers advice on training and details of funding packages. Its College of Production (COP) website has free online training videos and podcasts on journalism, production, technology and broadcast work. It's knowledge sharing available to all. You can learn how to produce and present for radio, what makes a good radio demo, editing, reporting, writing, broadcast technology, explore BBC apprenticeship schemes and BBC production trainee schemes. The videos provide a fascinating look and real insight into the different job roles and what each entails, taking you behind the scenes in TV and radio production.

The BBC Production Talent Pool (PTP) is one of the main entry routes into production-based roles across TV, radio and online at the BBC. It offers paid entry-level work. They have windows of recruitment and operate like a temp agency, placing successful recruits into programming areas as short-term jobs come up.

If you have taken part in the PTP you are eligible to apply for the BBC Production Trainee Scheme, a highly competitive and fast-track traineeship in TV and radio, across several different locations. For radio in particular, the BBC run a Radio Journalism Apprenticeship Scheme for applicants interested in speech radio, such as *Woman's Hour* on Radio 4, or *Outlook* on the BBC World Service.

The Radio Academy is the radio industry's professional membership organisation. It runs the Radio Festival – the annual conference – plus seminars, debates, masterclasses, networking and workshops. These offer opportunities for everyone from the national networks to individual podcasters to discuss the broadcasting, production, marketing and promotion of radio and audio. If you are an active participant in radio stations that are members of the Student Radio Association, Hospital Broadcasting Association or hold a current Ofcom community radio licence you qualify for free affiliate membership. The Academy runs a free web service including Knowledge Bank, featuring training guidance, work experience, getting a job, volunteering and CV advice and lists of radio job vacancies.

In the summer, Radio 1's Academy is a week-long event of workshops and networking to help kick-start a radio career. Former Radio Producer and presenter Lisa Kerr is a Fellow of the Radio Academy. What training does she recommend?

> The most important thing is to listen. Listen to every kind of radio and do it with a critical ear – that is, work out what the presenter is doing and why. Do it in the company of some really experienced producers – either by sitting with them in person, or by reading critiques of programmes and then listening to the output to understand the analysis.

Get as much experience as you can by volunteering for local, community or hospital radio where you can acquire skills such as setting up mics, interviewing, editing, using playout software, networking, communication and working in a team.

Some presenters just learn on the job. Actor and presenter Danny Steele has presented radio shows for Juice 107.2 in Brighton, BBC Radio Manchester, BBC Radio Bristol, ONFM Radio 101.4, Shoreditch Radio and Hoxton Radio. 'You do receive training, and at the time it's always a panic as you think you'll never

remember what to do. But after a few tries it becomes natural and just an extension of what you say and do.'

Jill Kenton's radio presenting credits include BBC Radio London 94.9, Hayes FM 91.8 and Time 106.6 FM. She describes her radio training experience:

> When I started at Time 106.6 I sat with another presenter for a fortnight and watched them drive the desk. I found it very complicated, from heading up to the 'top of hour' news; getting the right fader up in time to link to the travel, the list goes on. I thought I would never pick it up but I did. Now it is like riding a bike, I love it – it's always challenging but it keeps you on your toes!

Student radio

Student radio is a thriving scene. More than 70 student radio stations in the UK are members of the Student Radio Association, a body that supports and acts on behalf of student radio in the UK. Radio can be taught as a single subject, or with Film and TV, embedded within Media Production, Broadcast Journalism or even Media Performance and Music Technology, so research a wide range of media courses to find those that teach Radio within the curriculum.

Student radio stations can be found in universities and colleges across the UK such as 107 Spark FM at the University of Sunderland, Blast at the University of West London, Forge Radio at Sheffield University, Nerve Radio at Bournemouth University, Wired at Goldsmiths College, University of London, and The Voice at Runshaw College, Lancashire, to name a few. Some stations are run by the student union, some are community radio stations; often there are opportunities for non-radio students to take part, and volunteering for student radio is an excellent way in to the industry. You can listen live on radio or the Internet – see the Student Radio Association website for details.

Tom White ran his own student radio show on Luton FM while studying for a Media Performance degree. He became a runner at Sky Sports, then editorial assistant and worked his way up to become a presenter for Sky Sports Radio and he is now a presenter for Sky Sports News HD.

BBC Radio 1Xtra producer Dellessa James and Kiss FM presenter Melvin O'Doom both studied radio at university. How did student radio help Melvin to be where he is today?

> There is no direct route into radio and TV, everyone has their own journey to tell. I met Rickie (Haywood Williams) at university, we gained

work experience, freelanced in radio, won a competition, got signed up by an agency who pushed us, and now we're at Kiss FM. University taught us life skills and technical skills, but work experience is the key. Whatever works for you, as long as you learn your trade.

What makes a good Radio Presenter?

Our experts share their thoughts . . .

A successful radio presenter should be engaging, have humour, and knowledge. When I was a youngster I loved listening to Trevor Nelson on the radio as he was so knowledgeable and had such interesting stories to tell about R&B and lyrics; for energy you can't beat Tim Westwood who has so much passion for music; for humour, Ace and Vis on BBC Radio 1Xtra, and Steve Jackson from Kiss FM. Radio is an intimate form, an intimate medium, and I like to make listeners smile for a second. If I can find an opening to make people smile I've done my job.

Melvin O'Doom

Someone who is excellent at listening and isn't afraid to share their own innermost thoughts too. You need to also be good at speaking one-to-one – not one-to-many.

Emma Barnett

Great radio presenters know how to have a conversation with the person that matters most: the listener. They think less about themselves and more about the person they're talking to.

Lisa Kerr

I think there are many different qualities that make a successful presenter – ambitious, resilient, hardworking, team player, good communicator, good listener, self-starter, someone who is good at taking direction, strong improviser and, overall, I believe someone who has a unique voice or personality that will stand out from a crowd.

Dellessa James

Practical tips for radio presenting

Listen to a wide variety of output and try to analyse what works and what doesn't for each market, and how presenters talk to their listeners. What are the key points to remember when presenting on radio? Janey Gordon, Project Manager at Radio LaB, advises: 'Listeners are often by themselves, in the shower, bedroom, car, kitchen. Speak to one person as a warm friend.' This is similar to TV, where presenters should imagine one viewer, no matter how many thousands or millions of people are actually tuning in.

Should the presenter's voice and presentation change depending on whether it's TV or radio? Julian Worricker – BBC TV and Radio News presenter and BBC Presentation Trainer – says:

> In terms of the voice, I don't think anything changes. When presenting the news, it's vital that the presenter – on either medium – conveys meaning and understanding to the words he or she is saying. It's always about storytelling . . . and that doesn't mean shouting when the story is bigger, or rushing when the story is exciting. The viewer is not daft; they can work out for themselves what's important, what they want to hear more about, and what they'll happily ignore."

How should you start? Radio Lecturer and Radio Producer Jonathan Marsh gives these practical tips:

- ❏ Sit or stand approximately a hand's width away from the front of the microphone.
- ❏ Use the windshield provided with the microphone to help reduce wind noise, breath noise and plosives, such as 'P' and 'B' sounds.
- ❏ Aim for consistent audio sound levels, particularly when there are two or more presenters / guests on the microphone.
- ❏ Avoid banging the desk that the microphone is placed on, as the microphone will pick up any vibrations.
- ❏ Avoid wearing jewellery and clothing that makes a noise.
- ❏ When presenting, or editing a pre-recorded programme, do not 'crash' into the vocals in a song playing under the voice.
- ❏ Have up-to-date and accurate cues and information close by.
- ❏ Cues should introduce a topic and put the topic into context. They should be concise and accurate with short, sharp and punchy sentence structures.
- ❏ Think ahead. Ask yourself, what is coming up next on the programme?

❑ Regularly refer to your programme running order to check your programme is running to time.

❑ The listener is at the heart of any radio station.

❑ Involve the listener by reading their tweets, texts and emails, and putting callers on the air.

❑ Address the listeners as singular. Do not say 'Hello everyone'. This is not personal. Say, 'Hello and welcome to the programme, it's great to be with you today . . .'

Radio is a much simpler medium than TV and the desks are designed to be operated by non-technical staff, but you should aim to be very good at it to give as smooth a performance as possible. You will also need to be very familiar with radio editing software if you are going to edit interviews and create items. Adobe Audition is very common, but there are other packages.

Here are some practical tips for radio editing, again from Jonathan Marsh:

❑ Editing should sound seamless when listening back. No one, not even you, should notice that you have edited the audio.

❑ Do not 'over-edit' so that a person talking does not breathe and sounds unnatural and robotic.

❑ Carefully listen back to any audio you have edited to check it still makes sense.

❑ Aim for consistent audio levels.

Plan and prepare your show before you go on air. What topics do you want to talk about? Do you have any features to include? How do you want to structure your show? Don't talk over songs or the listener will get irritated. It's fine to talk over songs when you're a DJ, but not on the radio.

twenty-five
Reels and Breaking In

Reels

We all know the importance of making a good impression quickly – talent show judges and audiences make snap decisions as soon as a performer begins their act. The same applies to radio demos; decisions can be made within the first few seconds.

Former BBC Radio Producer and presenter Ann Kaye says:

> I once watched a programme controller going through a pile of demo tapes. He listened to most of them for the first ten seconds then threw them on the reject pile. So make the first ten seconds count, don't start with a long piece of music. And personalise your voice reel for the station you're sending it to, don't just make one and send it to everyone.

Radio presenter Danny Steele agrees:

> Make lots of demos and don't ever put weather/traffic links in them unless specifically requested! Your demo is the single thing that will get you noticed. It should be two or three minutes, make every second count. The first 20 seconds is the most important, this is your smash and grab time – put your best links here.

Janey Gordon, Project Manager at Radio LaB, says a demo can stretch to three or four minutes but emphasises:

The first ten seconds will mean that the next 30 seconds will be listened to and the first 40 seconds might mean the following minute is listened to. So front-load with the very, very best bits! Don't save the best bit until last, it will never be heard! It should be a real reel, so get involved in student, hospital, community radio to learn the craft, record everything, be highly selective and develop a showreel.

As with TV presenter showreels, focus your reel on what kind of radio presenter you'd like to be. Are your strengths in speech, music, interviewing, interaction with the listeners or particular genres? Don't try to copy someone else, be yourself. Create a soundcloud, mixcloud or audioboo file, and send the links.

Award-winning Radio presenter Emma Barnett says a reel should contain 'something serious, something fun and something totally different'.

Breaking in

Do not enter radio because you think it might be an easy route to becoming a TV presenter (it isn't) – see it as a career choice that may lead to TV opportunities in the future. Former Radio presenter Lisa Kerr advises: 'Be specific. Know what you want to do and what it is you can offer. Anyone can say they're hardworking and passionate – you have to *be* those things and find a way to demonstrate it.'

Even if you produced radio at university or college, be prepared to go back to basics, offering to answer the phones and make the tea. Ann Kaye received regular approaches from students looking for work when she was a radio producer.

> One of my first questions would be 'Do you listen to the programme?' You would be surprised how many didn't. Sadly though, life changes and certainly in the BBC it is no longer possible to make informal approaches, people need to go through the system. But there are more opportunities in community radio to explore – and most stations in that sector rely on voluntary help.

Research radio station websites to find out who to contact, and get their name and title correct. CVs and covering letters can end up in the bin if they are not presented well.

Ann Kaye says: 'I once saw someone send their CV with a teabag and a chocolate bar attached, saying sit down and have a cup of tea and a biscuit while

you listen to my showreel. Very clever. I would listen to that one, wouldn't you?'

Keep up-to-date with what's happening in radio by listening, reading the latest industry news and networking. Find a station near you or one that is broadcasting topics you are interested in. Could you contribute to their programming content? Are they making programmes that reflect your expertise? Ask if they offer work experience, placements or other opportunities.

The Community Media Association (CMA), was set up in 1983 to support community radio, but now represents community TV and Internet-based projects for the community. It is recognised by the government, Ofcom and the industry as the voice of the community media sector. It can assist in finding work experience opportunities and volunteering schemes for programme assistants, journalists, producers – no previous radio experience is necessary. If you want to start your own community media, contact the CMA. Its map will help you to find your closest full-time licensed community radio station.

The Hospital Broadcasting Association is a national charity that represents more than 200 individual hospital radio stations. Volunteering for hospital radio is another excellent way to start a radio career.

Another destination to consider in your broadcasting career is British Forces Broadcasting Services (BFBS) Radio, set up to entertain and inform British Armed Forces around the world – it currently transmits music and speech radio to 23 countries.

As in the TV industry, independent production companies make radio programmes for broadcasters, so widen your research by listening to the credits at the end of programmes. For example *Gardeners' Question Time* is a Somethin' Else production for BBC Radio 4, and *A Family Business: The Chaplin Legacy* is a Ladbroke production for BBC Radio 4.

What qualities do you need to get started? Danny Steele says:

> You need to be likeable, that's most important. Radio is a small and incredibly competitive industry and it has no time for divas. Please note, being likeable is different to being eager to please . . . that's just irritating. You also need a thick skin and tenacity to get through the door.

How did Danny break in to radio? 'I started in a few local community stations. I just rang up the director of one on a Friday afternoon and managed to blag a bit – he offered me a live three-hour show the following Sunday . . . two days' notice! It's at times like that you sink or swim.'

Radio presenter Jill Kenton adds: 'The trick is to have a personality and something to say – always good on talk radio!' So how did Jill get started?

Jnet Internet Radio was the first station I approached. I cold-called them to ask if they needed a contributor with a fashion touch, and ended up with my own weekly show. After that I approached Hayes FM, and landed my first community radio job and worked as the afternoon presenter with another presenter, Phil Dave. I then approached Time 106.6, which broadcasts over the areas of East Berkshire, South Buckinghamshire, North Surrey and the Heathrow area of London. I sent my demo in and was offered the afternoon presenting slot. I remained there broadcasting to around 20,000 listeners for two years.

You need to get a voice reel together, that is crucial. Hire a studio and mock up a show that would show your personality and style. Build a website – you don't have to spend loads, just two pages would do, with links to your audio. Then start circulating your audio and links to all local radio stations, including community-based ones. A good place to start is community, but don't expect to be paid; do this to get the feel of radio.

However, Radio Lecturer and Producer Jonathan Marsh feels that voice reels are not always necessary when looking to volunteer in radio.

Experience, knowledge, a willingness to learn and adapt quickly along with using your own initiative with creativity is a much more desirable proposition. Ensure your CV is up-to-date and contains all the correct and relevant information that is going to attract a prospective employer. Remember to include all relevant jobs (even if unpaid / voluntary – as this shows determination and dedication) and work experience.

The future of radio

What does the future hold for radio? Radio presenter Emma Barnett predicts: 'Music radio will become more niche, as mainstream channels invest less and less in talent – beyond breakfast shows – while speech radio will remain in rude health – while the BBC is around.'

Radio Producer Dellessa James feels:

Radio is a very important multi-medium and it will continue to grow and adapt along with technology, the Internet and the audience's needs. With services like the BBC Radio iPlayer app, Radio Player, TuneIn Radio and free podcasts available, listeners and subscribers now have more control than ever on what content they can watch, share and listen to.

According to Sound Women on Air, a networking and development group for women working in UK radio and audio, of 30 stations monitored across the UK in 2013, only one in five radio presenters were female. This research also revealed that there were no examples of two women presenting breakfast or drive-time programming.

Fari Bradley is an Experimental Music DJ and speech broadcaster working with UK sound-art radio station Resonance 104.4FM. She is a Leader at Sound Women on Air.

> The Internet and phone apps have really diversified radio listening, making it a great deal more international and micro-local. As we're competing with an increasing amount of algorithmic playlist platforms (streamed music selected according to your taste), I think the role of the presenter will have to reinvent itself in order to become more vital. Otherwise we might see the end of the spoken word on music shows altogether one day.

To do list

❏ Listen to a wide variety of radio stations.
❏ Explore work experience opportunities.
❏ Network within the radio scene.
❏ Acquire radio training.
❏ Increase your online profile by recording and uploading audio demos.

Click, read, discover

General info

www.bbc.co.uk/radio/stations – for a full list of BBC radio stations
www.ofcom.org.uk – for information about radio licences and stations
www.commedia.org.uk – Community Media Association
www.radioacademy.org – for debates, masterclasses and networking
www.hbauk.com – Hospital Broadcasting Association
www.theradiomagazine.co.uk – magazine for the radio industry
https://audioboo.fm – to record, share and save audio
www.studentradio.org.uk – student radio
http://web202.ssvc.com/radio – British Forces Broadcasting Services Radio

Training

www.creativeskillset.org – training, funding and career advice
www.bbc.co.uk/academy – training and development
www.bbc.co.uk/careers/home – work experience and trainee schemes
www.bbc.co.uk/programmes/p017f6dt – Radio 1's Academy for workshops

Jobs and networking

http://radiotoday.co.uk – industry news and jobs
www.thepips.co.uk/website – career advice in radio, job listings, coaching
www.mediauk.com – for job vacancies in radio and a list of commercial radio
 stations
www.soundwomen.co.uk – promotes women in radio
www.mediauk.com/radio/jobs – for radio jobs

US

http://tvandradiojobs.com
www.indeed.com/q-Radio-jobs.html
www.radiojobsonline.com
https://careerchannel.silkroad.com
http://careerpotential.com/career-news-events/career-potential-news-
 coverage-broadcast

Books

McLeish, R. *Radio Production*, 5th edition. Burlington, MA: Focal Press, 2005.
Stewart, P. *Essential Radio Skills: How to Present a Radio Show*. London: Methuen
 Drama, 2010.

Viewing radio

www.youtube.com/user/bbcradio1 – view BBC Radio 1 music on YouTube
www.bbc.co.uk/5live – watch BBC Radio 5 Live via their webcams

Final thoughts

I hope you have found inspiration in the case studies, revealing interviews and valuable comments from the wide range of experts featured in the preceding chapters.

To make the most of this handbook, be an active reader rather than a passive one. I've suggested lots of to do lists – but they will only work if you actually do them! Make yourself an action plan based on the lists and the resources that are relevant to you. The main message is that you can make your career and improve your chances of success. As I said at the beginning of the book, your personality and motivation are key to making change – with a bit of luck along the way!

Now it's over to you! So what are you waiting for?

List of Contributors

Part One – Reality Check

Chapter 1: Personality Check

John Byrne, Entertainment Industry Career Adviser, *The Stage* newspaper
Darsh Gajjar, Employability Adviser in higher education
Kate Russell, TV presenter, *Click* (BBC)

Chapter 3: Marketing Check

Del Brown, Live Director/Vision Mixer, QVC
John Byrne, Entertainment Industry Career Adviser, *The Stage* newspaper
Sarah Jane Cass, Senior Talent Agent, Somethin' Else
Cindy Dean, Senior Editorial Assistant, *Spotlight*
Susan Etok, Science and Technology presenter, BBC Expert Women scheme
Paul Fryer, Digital Marketing Manager in higher education
Darsh Gajjar, Employability Adviser in higher education
Michael Joyce, Founder, Michael Joyce Management
David McClelland, TV presenter, *Rip Off Britain* (BBC), Journalist, Technologist
Kerrie Newton, TV presenter, Model, Stylist
Colette Quartermain, Business presenter, BBC Expert Women scheme
Claire Richmond, TV Producer, Talent Hunter, Founder, findatvexpert.com
Fran Scott, Science TV presenter, *Absolute Genius with Dick & Dom* (CBBC)
Matthew Tosh, Science Broadcaster
Andrew Wilson, Founder, Cloud9 Management Ltd talent agency

Chapter 4: Career Check

Sarah Jane Cass, Senior Talent Agent, Somethin' Else
Cindy Dean, Senior Editorial Assistant, *Spotlight*
Nicole Harvey, Actor, Voiceover Artist, presenter
Michael Joyce, Founder, Michael Joyce Management
Fran Scott, TV presenter, *Absolute Genius with Dick & Dom* (CBBC)
Andrew Wilson, Founder, Cloud9 Management Ltd talent agency

Part Two – On the Case

Chapter 5: Children's Presenting

Michael Absalom, TV presenter, *Xchange, Best of Friends, Sportsround* (CBBC)
Kerry Boyne, TV presenter, finalist on *Blue Peter – You Decide!* (CBBC)
Steve Cannon, Producer/Director/Script Editor, CBeebies
Gemma Hunt, TV presenter, *Swashbuckle* (CBeebies); *Xchange, Bamzooki* (CBBC)
Billy Macqueen, Co-Founder, Darrall Macqueen Ltd, children's TV indie
Sharon Miller, Children's Writer, *Thomas & Friends, Bob the Builder*
Alison Ray, Children's TV Producer, CBeebies, CITV

Chapter 6: Corporate Presenting

Debora de Rooy, TV presenter, *Financial Times Ltd*
Nicole Harvey, Actor, Voiceover Artist, Web presenter
Colette Quartermain, Magazine Editor, Business presenter
Paul Tizzard, Live Events, Radio presenter
Michelle Witton, Actor, presenter, Lawyer

Chapter 7: Financial Presenting

Ros Altmann, Pensions and Economics Policy Expert
Naomi Kerbel, Business News Editor, Sky News
Neil Koenig, Producer Business and Economics, BBC TV and Radio

Chapter 8: Food and Drink Presenting

Tomm Coles, Nutritionist, pagetandcoles.com
Robi Dutta, Executive Producer *Food and Drink* (BBC)
Rebecca Kane, Raw Food presenter and Author, shineonraw.com
Nicola Moody, Director Factual Programming, Optomen
Tony Tobin, Chef, TV presenter, *Ready Steady Cook* (BBC), *Saturday Kitchen*

Chapter 9: International Presenting

Sarah Coutts, TV presenter, Liquidation Channel, Rocks & Co., Gems TV
Nicole Harvey, Actor, Voiceover Artist, Web presenter
Louise Houghton, TV presenter, DWTV, London Live, *Balcony TV: Music Sessions*
Marie-Françoise Wolff, TV presenter, QVC, Travel Channel

Chapter 10: Local TV and Student TV Presenting

Tina Edwards, TV presenter, London Live, *Balcony TV: Music Sessions*
Martin Head, MD, Cloudscape Communications Ltd & Local Local Local Ltd
Louise Houghton, TV presenter, DWTV, London Live, *Balcony TV: Music Sessions*
Steve Perkins, Director, Local Digital News

Chapter 11: News Presenting

Susie Fowler-Watt, BBC *Look East* presenter
Alex Gerlis, former Head of Training, College of Journalism, BBC Academy
Jayson Mansaray, Arts and Culture Reporter, Arise News
Maxine Mawhinney, BBC News Anchor
Julian Worricker, BBC TV and Radio News presenter
Mark Wray, Acting Head, College of Journalism, BBC Academy

Chapter 12: Science Presenting

Susan Etok, Science and Technology presenter, BBC Expert Women scheme
Jim Franks, Executive Producer, Newton Channel

David Gilbert, Executive Producer, National Geographic, Series Producer, *The Gadget Show* (Channel 5)

Maggie Philbin, TV presenter, *Bang Goes the Theory* (BBC)

Fran Scott, Science TV presenter

Jem Stansfield, TV presenter *Bang Goes the Theory* (BBC)

Matthew Tosh, Science TV Broadcaster

Richard Wyllie, Producer, *Dispatches* (Channel 4)

Chapter 13: Shopping Channel Presenting

Anita Albrecht, Guest Expert, Ideal World

Del Brown, Live Director, Vision Mixer, QVC

Cate Conway, guest expert, QVC

Sarah Coutts, TV presenter, Liquidation Channel, Rocks & Co., Gems TV

Alison Keenan, presenter, QVC

Kerrie Newton, TV presenter, Model, Stylist

Paul Slater, presenter, Performance Manager, QVC

Marie-Françoise Wolff, TV presenter, QVC, Travel Channel

Chapter 14: Sports Presenting

Annie Emmerson, TV presenter, BBC, Channel 4, Channel 5, Sky, former Duathlete

Matt Lorenzo, TV presenter, Sky Sports, online Premier League

Graham Miller, former Senior Sports Correspondent, ITN for ITV

Christina Nicolaides, TV presenter, Eurosport, *Best of the Bets* (Sky)

Chapter 15: Technology Presenting

Jon Bentley, TV presenter, *The Gadget Show* (Channel 5)

Jason Bradbury, TV presenter, *The Gadget Show* (Channel 5)

David Gilbert, Executive Producer, National Geographic, Series Producer, *The Gadget Show* (Channel 5)

Mario Louis, former Researcher, *The Gadget Show* (Channel 5)

David McClelland, TV presenter, *Rip Off Britain* (BBC), Journalist, Technologist

Kate Russell, TV presenter, *Click* (BBC)

Chapter 16: Working in TV Production

Naomi Kerbel, Business News Editor, Sky News
Seema Pathan, TV presenter, *Match of the Day Kickabout, Sportsround* (CBBC)
Jude Winstanley, TV Production Manager, Founder, The Unit List

Part Three – Channel Your Ideas

Chapter 17: What To Do With Your TV Idea

Annie Davies, TV Producer, Journalist, Series Producer
Nicola Lees, Development Producer, Author *Greenlit*, Founder TV Mole

Chapter 18: Setting Up Your Own Internet Channel

Nigel Dacre, CEO, Inclusive Digital
Helen Hokin, Editor, *Foodtripper*, presenter, Travel Channel
Karin Ridgers, Founder, VeggieVision TV

Part Four – Using Video

Evan Brindle, Lighting Cameraman, Editor
Giles Webb, Lighting Cameraman, Editor

Part Five – Using New Media

Becki Burrows, Creative Director, Oh Deary Me
Gavin Stewart, Principal Lecturer, Media Arts
Andrew Wilson, Founder Cloud9 Management Ltd

Part Six – Using Radio

Emma Barnett, presenter, LBC Radio 97.3 FM, Women's Editor, *The Daily Telegraph*
Fari Bradley, Radio Producer and presenter, Resonance 104.4 FM

Janey Gordon, Principal Lecturer, University of Bedfordshire, Project Manager Radio LaB

Lawrie Hallett, Senior Lecturer in Radio, formerly part of Radio Team at Ofcom

Dellessa James, Producer, BBC Radio 1/1Xtra

Ann Kaye, former BBC Radio Producer and presenter

Jill Kenton, presenter, BBC Radio London 94.9

Lisa Kerr, Media Consultant, former Producer and presenter, Classic FM

Jonathan Marsh, Lecturer in Radio, BBC Radio Producer

Melvin O'Doom, Radio presenter, KISS FM, TV presenter

Danny Steele, BBC Radio Manchester, ONFM Radio 101.4, Shoreditch Radio

Julian Worricker, BBC TV and Radio News presenter

Acknowledgements

A huge thank you to all the TV presenters who I have trained over the years – this book could not have been written without your amazing hard work and success.

Thank you to the University of Bedfordshire for continuing to support the teaching of TV presenting, The Actors Centre and City Lit for giving me so many opportunities to coach presenters.

There are so many contributors to thank (more than 80!) – I truly appreciate your input, reviews, comments and interviews that helped to create this book.

Finally, thank you to Focal Press and in particular Kathryn Morrissey for your incredible advice and encouragement.

Kathryn Wolfe

Index